PROHIBITION
CHICAGO

PROHIBITION
CHICAGO

WAYNE KLATT

THE
History
PRESS

Published by The History Press
Charleston, SC
www.historypress.com

First published 2023

Manufactured in the United States

ISBN 9781467151566

Library of Congress Control Number: 2022949528

Notice: The information in this book is true and complete to the best of our knowledge. It is offered without guarantee on the part of the author or The History Press. The author and The History Press disclaim all liability in connection with the use of this book.

Virtue, honor, truth and the law have all vanished from our life.

—Al Capone, 1933

CONTENTS

INTRODUCTION

My father didn't always carry passengers in his cab. On some nights during Prohibition, he had a couple of beer kegs in the back and maybe an extra barrel strapped to the grille as he drove around Chicago. Everyone could see he was violating the law, but if stopped, he would just say, "I'm with the Neuriters," and be let go. The Neuriters were a bootlegging police family. This and other fascinating stories I heard from both the wild and the mild sides of my family made the era seem far richer than what could be found in books, and so as a former Chicago newsman I decided to offer you a glimpse into what the period was really like for those who lived in it. And explain how it all happened.

It may be that power corrupts, but in Chicago, organized corruption became political power. Perhaps no other major American city was so ripe for criminal dominance during the thirteen years when the devil found a new address. Chicago had become "the center, in fact, the capital of the prohibition booze business, a golden city of the age of the rum runner,"[1] as a newspaper observed in looking back. "All roads from the east, from Florida, from Canada, led to Chicago. Truckloads of whisky roared down from the north at night, resting in friendly barns and garages from dawn til twilight. Other trucks came from the east and south on unfrequented sideroads. Hidden stills within the city turned out '14-year-old bourbon' in fewer than that many days."

But the devil never comes uninvited. Voters turned out a reform administration and brought back a clownish mayor who had been financed

by criminal syndicates for more than a decade. Wanting to keep illegal liquor flowing, people also welcomed the return of a governor who sold pardons to hundreds of mobsters.

Laborers dropped by beer flats on their way from work, the middle class adopted speakeasies as a way of life and private clubs needed to keep replenishing their stock. An alderman, a judge and a Methodist minister were among the respectable citizens caught alcohol trafficking. You could buy liquor inside the city hall/county building and a police station. Such side businesses may seem colorful to us, but they were tied into a maelstrom of robberies, gangland murders and political violence.

The collapse of social standards infused the city with an adolescent craving for excitement, daring people to drive faster, drink to excess and in general experiment with life. More than ever, weekends turned into sexual adventures possibly with the added thrill of seeing hoodlums throwing their weight around. Every neighborhood was served, but the real money lay in supplying genuine liquor to the affluent, from stockbrokers to a popular newspaper columnist. Few in authority spoke out against the social breakdown since the rest were either directly benefiting from conditions or their silence kept them in office.

"It was a fantastic era," recalled a journalist. "It was possible for an outlaw to become exceedingly rich, politically powerful, and widely respected."[2] Hotels greeted big-tipping underworld figures, and fashion pages featured designs for speakeasy ensembles. Newspaper publisher Cissy Patterson gushed over Al Capone's manliness, and the mobster graced the cover of *Time*. As a woman enthuses upon meeting a handsome gangster in a film of the period, "A new kind of man in a new kind of world."

What was then the country's second-largest city outstripped New York in violence and craziness. Good people respected mobsters, set killers free and hated the police. But why were the times so far out of joint in just Chicago? Commenting about Capone's hold on the city in 1928, *New Yorker* writer Alva Johnson observed, "Physical conditions make the super-gang here impossible. Street traffic alone prevents it. There isn't room for beer [trucks]. A psychological factor also prevents proper arrangements being made with the authorities to flood New York with beer. The enforcement people feel that they must make a show of activity in New York to make the drys of other sections happy." In Chicago, federal "enforcement people" answered to the corrupt mayor.

Time called Chicago "the most notably criminal city in the U.S.," and that was before two carloads of white gunmen killed a promising Black

candidate and the St. Valentine's Day Massacre.[3] With Windy City public officials plugging into an endless current of corruption, the Chicago Crime Commission recommended firing every single policeman in the city to restore integrity. The city also introduced submachineguns into urban warfare and coined the phrase "taken for a ride."

Previous sources mention corruption here and there without comprehending how gambling rings, vice lords and bootleg gangs were a necessary part of the political structure. In fact, a special grand jury found that the long-standing political/criminal bond had created a de facto "super government" affecting every resident, from mayhem in the streets to the price of meat. None of this was secret; the newspapers carried at least hints of who was bribing whom, but the public did not want to stop enjoying the excesses of living.

Concentrating on the gangs would overlook the spirit of the times; however reckless, they were fun almost to the point of giddiness, even for those like my nondrinking aunts from Iowa. The world around them was so unpredictable that anything new might be tried, from dance steps to hairstyles. People seldom went anywhere alone; they usually were seen in clusters of buddies or office girls out for a good time.

Since most activities described in these pages were illegal and unprosecuted, we lack primary sources to steep us into the Prohibition milieu. An Illinois Association of Criminal Justice report in 1929 even complained about the "meager" police information on Capone and other gang leaders, and several infamous mobsters had no file at all. For those who did, the reports seldom carried the result of indictments, leading the compilers to assume that countless cases were dismissed despite the evidence—more likely, the charges were lost or led to bribed acquittals. For this book, we must do the same.

The Association of Criminal Justice cited newspapers as our best information about gangs. As I went over one to four of them front to back from each day of the period, commonly repeated legends fell away. The period is told largely chronologically to avoid conflating cause and effect, and only credible sources have been used. Most of the information in *Prohibition Chicago* has never appeared in books before or in articles that were written after the era ended. For simplicity, criminals are identified by the names they are best known by.

I

THE GANGSTERS' MAYOR

*The most corrupt and degenerate municipal administration
that ever cursed a city.*

—*Robert Isham Randolph,
president of the Chicago Association of Commerce*

1
1920

Goneral Police Superintendent John Garrity assured Chicagoans that his men would not disturb their public drinking on the final night of John Barleycorn, January 16, 1920. Even so, many patrons wore hip flasks for the way home, and a newspaper noted that "traveling bags gurgled." At the stroke of midnight, musicians at one hotel played a dirge while liquor was carried out on a bier. For the next few hours, liquor stocks at all hotels and saloons were taken to warehouses for the duration.

A few minutes into the new era, undersized North Side safecracker Dean O'Banion noticed an open-bed truck pulling away from the downtown Randolph Hotel. On a whim, he lifted the tarpaulin and saw whiskey crates. Dean stepped onto the running board, grabbed the driver in a headlock and knocked him out with a fist clenched around a roll of nickels. This was America's first recorded "whiskey robbery" of Prohibition; the word *hijacking* had not yet been coined. O'Banion—future leader of the North Side gang—pulled the unconscious driver out and drove the rig to the West Side auto garage of his friend Sam "Nails" Morton, who ran a chop shop.

In the country's second whiskey robbery, masked men later in the first hour of the epoch tied up a watchman in a Chicago freight yard and stole $100,000 in whiskey legally set aside for medicinal purposes. A few hours afterward, federal agents in Peoria, Illinois, found men piling whiskey crates onto trucks at a distillery. The owners called it a burglary, but they evidently planned the theft to sell the liquor on the black market. A few days later, an army sergeant at Fort Sheridan in the northern suburbs was caught helping

liquor thieves transport their haul. The first-ever federal speakeasy raid in America occurred on January 28 at Chicago's Red Lantern, a North Side "whoopee joint"—that is, a speakeasy cabaret.

During most of Prohibition, Mayor William Hale Thompson was secure in office because of his hypocrisy, African American support, talent for playing down to crowds and, most of all, underworld connections. Gangsters could apply their energies so freely to the new opportunities because the administration virtually invited them to break the laws and share their profits with them.

"Big Bill the Builder" was born in Boston in 1867, but the family moved to Chicago the next year because his mother had inherited property there. His bullying father made a fortune in downtown real estate and was elected to the Illinois state legislature, surrounding his young son with politics, money and deal-making. The son seems to have been intelligent but lacked an active mind. Rather than be subjected to discipline at an eastern school, Bill chose to live on a Wyoming ranch his father had bought as an investment. Bill wanted to be liked for himself rather than his father's money, and popularity would always be important to him. In 1888, he took over his father's Nebraska ranch and enjoyed being around gamblers, whores and chicanery.

Young Thompson hurried back to Chicago in 1891 for his father's funeral and was impressed by all the civic leaders in the cortege. He obliged his mother by remaining in the city so he could take care of her and his two younger brothers and handle the family's $2 million estate. Somehow these ordinary circumstances combined to produce perhaps the most disastrous mayor any major American city ever had.

When Bill Thompson took over the family, Chicago had only recently become a first-class city. The overgrown frontier town was swept away by the Great Fire of 1871, and although the city saw the world's first modern skyscraper its laws were so backward that juries were allowed to decide cases by flipping a coin until early in the twentieth century. By 1915, the city had become a busy center of hotels, restaurants and clubs serving business executives, meatpackers, speculators and commercial travelers. But Chicago lacked the rigid social order of Boston and New York and even the stabilizing effect of a solid middle class. People eager for a fast buck knew it as a get-what-you-can kind of town.

Its vice lords generally cooperated with one another from within agreed-on territories and maintained good relations with the police and city hall, setting a pattern for all that would follow. Regarding this period, Chicago Crime Commission director Vigil W. Peterson said the underworld, and not

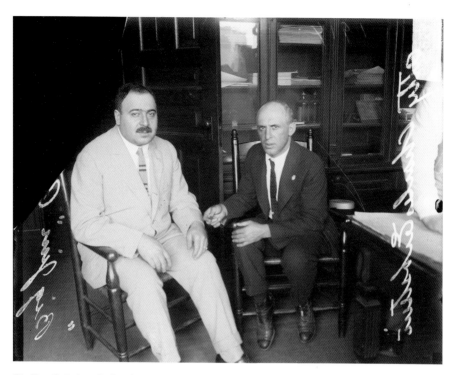

Big Jim Colosimo before he was killed for *not* engaging in bootlegging. *DN-0063234,* Chicago Sun-Times/Chicago Daily News *collection, Chicago History Museum.*

the voters, "constituted the most powerful political force in the city."[4] The whoremongers, those pillars of the city's underworld, sought a mayor they could count on, and they largely financed Thompson's campaign while he wore the mask of reformer.

With the voters mattering little, Thompson was put in office by vice lord Jim Colosimo, slot machine chief Herbert Mills, gambling king Matt Tennes and some unseen string-pullers in state politics. All of them conspired to run the city wide open—that is, to enrich themselves by protecting lawlessness.[5] Thompson's debt to the criminal element was seen early, when he fired a prosecutor who had supplied the police with a list of brothels to raid. This was followed by an unbroken succession of five corrupt chief prosecutors, allowing police captains who had been chosen by precinct-level politicians to be familiar with every dice-thrower and woman in a doorway. Though Mills and Tennes lost influence during the World War I period, "Big Jim" Colosimo seemed well on his way to becoming a major behind-the-scene force as Prohibition neared.

Congressman Fred Lundin served as a Thompson strategist while working on side schemes such as massively cheating the underfunded Chicago School Board. Rather than offering anything to benefit the city during his reelection campaign, Thompson—often appearing in a cowboy hat—denounced the British to win the Irish and German vote. He later moved the boundaries of the vice district from the Near South Side's Second Ward to the all-important downtown First Ward to increase his share of the graft.

Thompson allowed Colosimo—later an early victim of gangland violence—to reopen a major "house" after the previous mayor shut it down. In return, Big Jim handed over large bribes collected from fellow vice lords. There may be only one explanation for the already wealthy mayor's mindless greed: bribes made him feel important and appreciated. But his real power source were the two African American wards. Census figures released in late 1920 showed that the city's Black population had jumped more than 148 percent in ten years. This and a 21 percent increase in the Caucasian population, largely from immigration, brought the population to nearly 2.7 million and rapidly growing.

With few employment opportunities, many Black Chicagoans gambled on a weekly lottery called "policy," and no "black belt" politician could win office unless he supported the wheels. With no other white politician even having a path to this demi-world, Thompson used white businessman-alderman George Harding as his liaison. Harding secured 97 percent of the African American vote for "Big Bill," and now no one could defeat Thompson except himself.

The Most Hated Law

The Volstead Act of 1919, which went into effect in early 1920, represented the wishful thinking of small-town Protestant America forced on crowded cities already struggling with crime. Hoping to end the drunkenness that increased with immigration, many upstanding citizens sent contributions to the national Anti-Saloon League, unaware that the group was a swindle at its core, with several regional directors diverting funds to their own pockets. The league had no real organization, just an executive committee of nineteen and one hundred glorified sales agents who whipped up contributions at the parish level. The league was widely rumored to be planting spies nationwide for blackmailing lawmakers into voting for Prohibition, whether they supported it in their hearts or not.

By 1916, the conspiracy was dipping into a reserve of nearly $1 million to elect men to both houses of Congress. A popular vote would have defeated any anti-drinking law, but the growing movement focused on leading citizens. A major Washington, D.C. bootlegger said most congressmen and senators who voted for the measure were frequent drinkers in their office or at home. The *Chicago Herald and Examiner* and the *New York American* obtained documents showing that the league intimidated federal officials into appointing Roy Haynes as the nation's first Prohibition commissioner precisely because he was ineffectual.[6]

The law went against human nature. Saloons were largely places of friendship where people who could not understand English learned about events affecting them, and salesmen, businessmen and real estate agents used convivial liquors in their profession, sometimes drinking to "seal the deal." All this cordiality ended in early 1920, replaced by the most widespread drunkenness the nation had ever seen.

Anyone abstaining was mocked and encouraged to try a few just to be sociable. Women, who had been barred from most saloons months before, quickly learned to drink alongside men, and men hoped that a few drinks would make their dates forget their reservations. Numerous lawmakers had urged that the measure outlaw only hard liquor, since beer was less of a problem, but the league insisted on forbidding everything capable of giving a kick, in effect creating a demand for bootleggers. After the amendment took effect, the league forestalled congressional redistricting to block the election of anyone favoring repeal.[7] Only the league knew how long Prohibition would last: it would last as long as well-meaning donations came in.

At first, the noble experiment seemed a success in Chicago, with more than fifty saloonkeepers pleading guilty to Volstead violations on the same day in January. Yet witnesses told a federal grand jury at the same time that the man in charge of implementing liquor laws in the region, District U.S. Internal Revenue director John Dombrowski, was already taking bribes.[8] He was fired in embarrassment but never tried.

No one can even estimate how many people were making liquor in those first weeks. One needed only some jugs, ordinary ingredients and hardware easily sold in stores with hardly a wink. Federal agents suspicious about South Side undertaker Thomas Barosko found two stills hidden inside his coffins.[9] Since the public was sure that such a contrary law would not last long, "the parties became wilder, the dancing bolder," a witness to the times reminisced; "men and women wanted to enjoy themselves while they could." A young man told a reporter that "ninety-nine out of a hundred of

us couldn't tell good liquor from bad. We don't know how to drink or when to stop....The main reason why we drink, however, is to appear big in the girls' estimation, and not as babies." Young women, indeed, would prove the spark plugs of the era.

Wealthy citizens denounced a harsh sentence imposed on the operator of two upscale speakeasies, and before long, nearly every building in the downtown Loop district had some kind of liquor arrangement going on. Since federal agents took bribes from the operators, a volunteer crime-fighting group called the Chicago Committee of Fifteen gave authorities a list of establishments to shut down. They stayed open.

Patrons arrived at downtown speakeasies in formal clothes, some of them trying the new sport of "slumming," but in neighborhood "joints," most men wore suits and their dates were in clothes suitable for the office. Now that proper women drank and socialized with men, they prepared for their nights out by reshaping their mouths with lipstick and patting their exposed backs and shoulders with rice powder. Shy girls were no longer admired for their virtue. A flapper in a 1920s film rehearses her quick-step by a mirror and then tells admirers she is proposing a toast "To myself!"

The most popular place to buy liquor early on was the neighborhood drugstore. Many physicians would fill government prescription forms for three dollars apiece. Pharmacists would then hand over one pint of 100 proof. In time, the average price for a pint of prescription liquor would rise to seven dollars, although in 1919 it had been a buck. Eventually, many doctors simply sold their prescription books. The absurdity of the system was shown in a Mack Sennett short, where a man drains a wineglass at a celebration and a dialogue card has him saying: "Ahh, I must have that prescription refilled." Drugstores at first marketed the real product for medicinal uses but eventually dealt in "rotgut." We know this because tasters for future reform mayor William Dever would report that samples "burned their tongues, and that when they touched their matches to it, immediately there was a flame."

Chicago's first headlined murder victim of the period was not a bootlegger but labor racketeer Maurice "Mossy" Enright. In some ways, his life and death hinted at what was to come. The Irish American worked as a newspaper slugger during the circulation wars and later killed a dynamiter in a quarrel at a downtown hotel. Witnesses kept disappearing, but one walked into court despite a shoulder wound. Enright was convicted and sentenced to life in prison, only to be pardoned in 1913 after members of the steamfitters union signed a petition to free him and an apparently paid-off witness recanted.

Under political protection by a multiple brothel owner, Enright busied himself with "labor terrorism" to infiltrate unions such as the one for street sweepers. Also eyeing their dues and wanting to use them as a political power was vice lord Jim Colosimo. He used beatings to ensure that his handsome bodyguard Michael Carrozzo was elected union president. Enright and two other men responded by firing at Carrozzo, but they missed, and the target and his accomplices retaliated by killing "Mossy" with two shotgun blasts from a slowly passing auto on February 2, 1920. This was the twenty-third union-related murder in the city since 1910 and Chicago's first recorded drive-by shooting.

Colosimo's background has everything to do with how Chicago took the turns it did during Prohibition. Following his emigration from southern Italy, he had seen how vice laws were being shrugged off in Chicago. Big Jim married a madam, and they grew heavy together. Victoria taught him how to run stables of young women, and he seems to have conducted his business as fairly as could be expected. Preferring administration to day-to-day work, he branched out into pool halls, opium dens and small restaurants. He is believed to be the first Chicagoan to pull various criminal activities together in harmony with city hall rather than just paying off police captains.

In 1911, Colosimo panicked at receiving a Black Hand extortion letter. As he told a friend, giving in would cost him his business from the payout and subsequent loss of respect. "They'd make a bum out of me," as he put it. Victoria suggested he ask her distant cousin John Torrio in New York to settle the problem. Torrio was small and quiet, unlike most street toughs in Brooklyn's infamous Five Points neighborhood, and was easy to underestimate. When he stepped off the train and met Colosimo, he found a large but still fairly good-looking businessman with a short mustache. Torrio went around asking questions about Colosimo's Black Hand demand, and before long, all three men involved wound up dead. Big Jim was impressed.

Real estate investors in the know thwarted city plans for turning the former whorehouse district into a park. Before long, middle-class venues mushroomed in the cleared area along 22nd Street between Dearborn and Wabash, rivaling more expensive places downtown. Colosimo opened a restaurant at 2126 South Wabash that was patronized by pickpockets, safecrackers and "loose women."

This was exciting to Torrio, who had been only two years old when his family arrived from Naples. He developed a street-level shrewdness, such as this advice from a Neapolitan card players' handbook: "Always try to

21

South Side gang boss John Torrio after an assassination attempt. He returned to New York with plans for a national crime syndicate. *DN-0096888* Chicago Sun-Times/Chicago Daily News *collection, Chicago History Museum.*

see your opponent's cards." He also brought other ideas from his homeland, such as that all administrations could be corrupted.

Torrio went from being chief bouncer at the restaurant to running several whorehouses under his boss's guidance. He also encouraged Colosimo to feature top bands in the café to capture the after-theater trade. The place blossomed into the centerpiece of a second downtown. The enlarged interior was painted rose and gold, and waiters balanced broad trays around the dance floor. A newspaper reported that the customers were "gamblers, and crooked coppers and lords and dukes of the badlands. But you could see, too, millionaires and merchants and bankers and novelists and teachers of kindergarten." High-stakes gambling went on upstairs. From midnight to nearly dawn, whistles blew for taxis, and chauffeurs sat in cars until their employers came out in dinner jackets and top hats. People not meeting the café's new standards were turned away.

Torrio established a headquarters in Colosimo's Four Deuces recreation building. The name came from its address, 2222 South Wabash. The first floor was a saloon, and a betting parlor took up most of the second floor. While racetrack action from around the country came over loudspeakers, Torrio worked on his ledgers in a small office on the other side. The third floor was a casino with a roulette wheel and tables for craps, blackjack and poker. The fourth floor held a brothel serving two- and five-dollar customers.[10]

With Colosimo's talent for organization and his city hall connections, he could have risen to crime czar. But he was not interested in Torrio's talk about using his First Ward influence to dominate liquor distribution in both downtown and the 22nd Street entertainment district. (South Side streets are identified by numbers outside downtown.) Big Jim had fallen in love with attractive young singer Dale Winter. He lavished money on her, went through a divorce, married her and neglected his enterprises.

Investors excited at meeting the liquor demand used neighborhood toughs to run rogue breweries or clandestinely convert watered-down legal beer into full strength at the few remaining licensed breweries in the city. Investors included Edward and Joseph Stenson, who owned more than ten breweries

in the Chicago area. The more active brother, Joseph, lived on exclusive Astor Street just off Lake Shore Drive and made political contacts at lunches in the Chicago Athletic Club. This enabled him to organize payoffs to the police, ward organizations and city and federal officials.

The Stensons gave up trying to work with love-struck Colosimo and saw that his right-hand man had a sharper grasp of what was needed. The brothers apparently let Torrio know they would be pleased if anything should happen to Big Jim soon, so that it would be mistaken for revenge in the Mossy Enright murder. A man resembling New York gangster Frankie Yale, who had taught Torrio crime basics, was seen casing Colosimo's café. On May 11, 1920, the forty-five-year-old bridegroom was shot in the head from the hatcheck bay before customers arrived. The $150,000 he had shown his silent partner, the not-yet-famous gambler "Nick the Greek" Dandalo, had disappeared along with $25,000 from his safe. Torrio may have known the combination.

No one had seen anything like Colosimo's funeral, the first gala burial of a murdered American criminal boss. Newspapers across the country reported that a crowd of more than five thousand attended, including city workers, aldermen, judges and state representatives. But in New York, Frankie Yale's political connections were so strong that the police refused to cooperate with Chicago authorities trying to gather evidence.[11]

Torrio took over the Stensons' West Hammond (Calumet City) brewery complex while the brothers retained ownership. He also may have assumed Colosimo's ties with the Thompson administration, in that the city never interfered with his beer distribution network as it grew into the South Side gang. This was, after all, Chicago's most vibrant time. Prohibition agents were not only generally inept but also thinly spread out, with the Chicago office responsible for all of Illinois, Indiana, Michigan and eastern Wisconsin. No wonder speakeasies sprouted everywhere.

Anyone borrowing at least $1,500 in startup costs could open one. The trick was to make the place look more expensive than it was so that customers would not question the huge liquor markup. The most successful places operated as restaurants, with attractive signs inviting the ladies, but Prohibition agents claimed an apartment building basement could be rented as a "speak" for $75 a month.

Early on, landlords asked for as much as $300 a month if someone wanted to run a "joint," but a federal judge ruled that charging speakeasy owners more than other business tenants made them partners in a conspiracy to violate the Volstead Act. Other middle-class places were fashioned out of

adjoining apartments once dividing walls were knocked down. Waitresses and chorus girls squeezed past each other in narrow hallways.

A good bar with a mahogany top would cost $200 at a U.S. marshal's auction, or for the same amount, a carpenter could make a counter from a rubber composition. The price of a large refrigerator was around $400, and kitchen plumbing with a dishwashing sink would raise the outlay by $100. Decorating the interior ran about $200; then there were $300 for furnishings and $150 for a small piano before college bands could be booked to play jazz. Installing washrooms would set the risk-taker back another $300, but waitresses would work for tips. Investors also needed to hire bartenders, bouncers, cooks, waiters and, if the place was large enough, hatcheck girls. Of course, every month the manager or front man would pay off the police captain and ward committeeman.[12]

Factory neighborhoods had "beer flats," where such people as assembly line workers and printers sat on one of several wooden chairs by a small table and bought doctored liquor or glasses of real beer drawn from kegs kept off to the side. Some beer flats had same-sex dancing with music from a phonograph.

Not everyone distilled and fermented "gin" in a tub. Working in an apartment kitchen, my uncle Oscar, an electrician by day, mixed cheap grain alcohol with glycerin and flavorings such as juniper juice. A chemical brought the fermentation down to sixteen hours. Since this produced relatively little alcohol, he, like countless others, filled the jugs with water from his bathtub faucet because the long necks would not fit in a hand sink. Small but wiry Oscar then waited for a North Side bootlegger to make his weekly pickup.

Those who could not afford to buy through bootleggers could manufacture ersatz liquor at their own risk. They mixed raw alcohol with gelatin for flavoring. To determine whether the results were safe to drink, they lit a small sample and hoped for a blue flame. While licensed breweries were allowed to remain open as long as inspectors confirmed they were producing only "near beer," former factories and other commercial buildings were converted into rogue operations for the real stuff. In one raid, every barrel of mash contained dead rats that had fallen in from the yeast and sugar fumes.

In Canada, the province of Ontario cashed in on the plight of its southern neighbor by stepping up the manufacturing of strong liquor varieties. The shipments went by boat to Detroit for truck convoys to locations such as Chicago or were taken by train to New York, where part of the consignment was put in Windy City–bound boxcars. Once the real liquor arrived, it was cut several times. Those who could not afford even watered-down "genuine

stuff" bought fake whiskey fashioned from such ingredients as amyl alcohol, fusel oils, ethyl alcohol, butyl alcohol, amyl esters and butyric acid. Some were poisons.[13] The plenitude of imitations increased the price for "the real stuff," and a chauffeur or maid might sell information about private reserves. But a chauffeur was beaten to death in the ornate home of Sherman Hay for trying to stop burglars from stealing the wealthy attorney's liquor stock.

Uninterested in the liquor racket, rough-looking Charles Reiser led a safecracking team that would evolve into the North Side gang. His members included Dean O'Banion and Earl "Hymie" Weiss. During an extortion raid, crooked detective Daniel Gilbert put a gun to Reiser's face as the thief was in the washroom and found enough safe-breaking nitroglycerin in the apartment to obliterate much of downtown.

Dean, often misspelled "Dion," was a short, moon-faced Welsh and Irish American who had broken away from his strict grandparents and hung out with thieves, gamblers and prostitutes on North Clark Street. Dean probably would have remained a thief if it had not been for the quick money of Prohibition. On his own, he led fellow safeblowers in hijacking liquor trucks and watering down Canadian whiskey as side jobs.

The Stenson brothers started trucking beer to Reiser's gang for North Side distribution in addition to bankrolling Torrio's embryonic South Side mob. The brothers also worked with the swiftly rising West Side team of Terry Druggan and Frank Lake. The two friends had the likable energy of Harold Lloyd and inherited a small, politically connected gang when their political boss was gunned down, probably for the Enright murder. Impressed by Druggan and Lake's clear-headed eagerness, the Stensons made them partners in three breweries furtively producing real beer. The generally nonviolent pals seem to have dealt exclusively in beer and learned from the Stensons the advantage of paying off state lawmakers as well as police captains and ward committeemen. Since they never fought their competitors, they were largely left alone for the entire period.

The Mossy Enright investigation hit a slowdown when someone in shadowy chief prosecutor Maclay Hoyne's office started providing information to the assassins. One witness was shot in an office in April 1920 an hour after supposedly visiting Hoyne in secret.

The affluent as well as blue-collar workers protested liquor raids such as one at the home of businessman Charles B. Smith near Mayor Thompson's Sheridan Road apartment. Although alcohol-related offenses were erupting everywhere, it was not always clear what sort of crimes they were. Police believed a $600,000 liquor burglary at the Sibley warehouse had been staged

by the owners to sell their stock on the bustling black market. The popular impression was still that there might be nothing more to alcohol trafficking than the local supplier, who could be a relative or an amiable neighbor.

That ended when federal agents smashed a $1 million liquor ring supposedly having ties to the Alderman "Hinky Dink" Kenna faction in city hall. Witnesses confirmed that "scores of federal officials and many Chicago policemen" were involved, according to a United Press account. Operating out of a Black-run speakeasy on 36th Street, the white thieves looted a warehouse with forged government withdrawal slips to serve the wealthy on Sheridan Road and Lake Shore Drive, now Du Sable Lake Shore Drive. By late October, all eight witnesses had been paid off or advised to disappear.

In this lively but relatively quiet year, certain gangs gained muscle and overtook smaller outfits, and with this additional income they bought political protection, sometimes apparently promising to help out on election day. But at least one politician headed his own gang: Nineteenth Ward alderman John Powers, whose ward straddled the Irish community and the expanding Italian neighborhood. Irish-born Powers kept his seat by gladhanding at ethnic weddings and bailing out Italian vendetta killers and Black Handers. His influence was so strong that the rising Genna family decided to remove him.

The six brothers arrived in the United States around 1910 and quickly learned to adapt. At the start of Prohibition, plump James Genna (pronounced JEN-ah) opened a "blind pig"—a storefront business selling strong beer from under the counter—and wanted to make wine to sell as well. This opened his eyes to all the policemen and federal agents with their hands out. In fact, the Chicago Way of bribing everyone on up would let the Gennas turn the Sicilian tradition of making alcohol at home into the cottage industry of the Nineteenth Ward.

Obtaining a government permit for manufacturing industrial alcohol, possibly with start-up funds from Torrio, the Gennas methodically distributed tons of corn syrup throughout their shanty community so that households could boost fermentation. The brothers paid most newly arrived Sicilians fifteen dollars a day, giving them hope their children might rise above the squalor. Before long, hundreds of families were turning out raw alcohol with ingredients and equipment costing just forty cents a gallon. Torrio would buy large cans of the unflavored product from the Gennas for two dollars a gallon, alter it to a semblance of one sort of liquor or another and sell the mixture to dives for forty dollars a gallon. For upscale speakeasies, Torrio

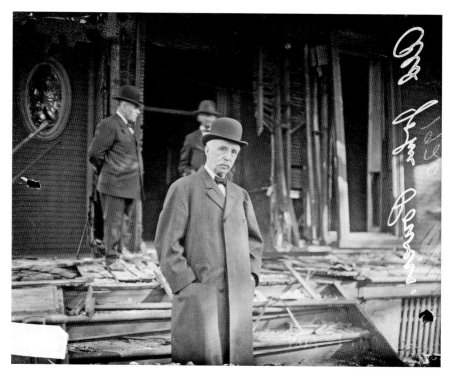

Alderman John Powers, an Irishman who used violence to hold on to an Italian ward. *DN-0072434*, Chicago Daily News *collection, Chicago History Museum.*

would provide quality liquor from Canada, with his mentor, Frankie Yale, supervising shipments leaving New York rail yards.

In time, there would be a bloody war between the Gennas and the Torrio/Capone outfit, but in 1920, Michele Merlo of the Unione Siciliana social organization remained the peacemaker. Merlo had risen from laborer to the most prominent Italian man of affairs in the city. He may or may not have been involved in the local Mafia, but he evidently understood criminal gangs and they trusted him. But the Gennas were too ambitious to abide by the status quo.

The first step was to support counterfeiter Anthony D'Andrea as ward committeeman. His election in April put him in charge of neighborhood patronage and let him nominate circuit court judges. With such a foothold in the ward organization, the Gennas dynamited Powers' front porch on September 29, 1920, and waited to see what he would do.

Gangs citywide were enjoying considerable freedom because Mayor Thompson was no longer beholden to anyone. In advance of the 1920

national convention at the huge Chicago Coliseum, the state Republican delegation dropped him because of what the press could bring up about his organization—such as how chief city attorney Samuel Ettleson, a former state senator, was said to be laying out the mayor's relationships with criminals.[14] Now on his own, Thompson chose to announce a personal slate of candidates at a political rally in the North Side's large Riverview amusement park on Saturday, July 10.

To a cheering crowd, he introduced former banker Len Small of Kankakee for governor; Judge Robert Crowe for state's attorney (Illinois is the only populous state using that title for chief prosecutor); and city hall bagman and general facilitator Morris Ellis for trustee of the Sanitary District, which conducted drainage projects in the city and suburbs. We have no evidence of collusion between Thompson and his candidates, but the actions of all three hand-picked men show there must have been. As governor, Small would bribe jurors in his embezzling trial and sell hundreds of pardons to the city's worst criminals; as state's attorney, Crowe would "lose" evidence and neglect to prosecute suspects in major crimes; and as Sanitary District trustee Eller would form a murderous political clique.

This unholy trio was just part of Chicago's climate of corruption. When evidence showed that a detective sergeant was stealing crates of warehouse whiskey, Police Superintendent John Garrity declined to investigate, "in that liquor is a federal matter." And regional Prohibition director Hubert Howard let the matter drop because "there is no end to the liquor graft in government forces," and therefore any investigation would be futile. Incredibly, Lynch remained on the force. So it was that few law enforcement officers made arrests as moonlight convoys brought liquor to the city night after night. Ahead of each rig would be a scout car, a wad of money in the driver's pocket for paying off anyone stopping them and possibly a gun in his lap to battle his way out of an ambush. A shotgun man watchfully rode in back.

No wonder Prohibition evils were spreading to the suburbs. When Melrose Park police chief Wienecke arrested a man in July for organized gambling, outraged citizens fired more than twenty bullets into the village hall and jail. Roused from his bed, pajamaed Wienecke hauled the gambler from his cell to the home of a magistrate. At the next election, citizens voted in a more understanding chief, and the western suburb remained gangster controlled for most of the thirteen years.

Bootleg shootouts were still uncommon in Chicago because union takeovers and robberies offered quicker returns. With Mossy Enright out of the way, tall and rawboned "Big Tim" Murphy controlled several labor groups and

other rackets. He used the relatively new technology of wiretapping to learn of the next money delivery to the Far South Side Pullman Bank. A gangster intercepted a twelve-year-old (!) courier to snatch a mail bag from a railroad station chute and speed away with at least $100,000.

At the time, jazz and sensuality were drawing white customers to South Side interracial "black and tan" nightspots, where the entertainers, waiters and bouncers were primarily African American and the patrons were integrated. At the Sunset Club, *Herald and Examiner* nightlife reporter Sally O'Brien saw kissing everywhere, including a couple who had met when the man cut in during a dance minutes before. At one table sat five men and one woman. Because a new police captain was cracking down on liquor laws—maybe he wanted a larger payoff—nearly every patron in another party ordered ginger ale for mixing drinks under the table with ubiquitous pocket flasks.[15]

Chicago's black and tan era abruptly ended on August 23 because of a shooting at the Beaux Arts Club on the upper floor of the politically protected

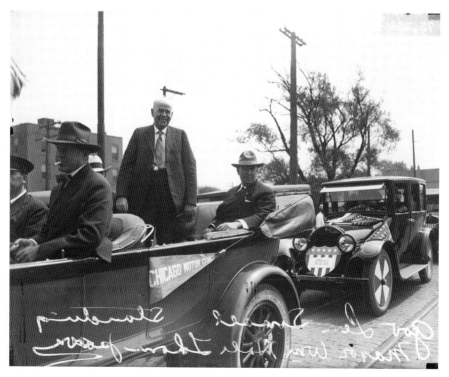

Crooked mayor William Thompson rides with crooked governor Len Small in a Chicago parade. *DN-0073336,* Chicago Daily News *collection, Chicago History Museum.*

Pekin Cafe at 27th and State. Two corrupt police sergeants quarreled over money with racketeer Sam "Nails" Morton and his bodyguard. Both sergeants were killed as seventy-five patrons, white and Black, crammed through the exits. The bodyguard was acquitted in the double killing after Morton spread money around. Since this was the second outbreak of gunfire at a black and tan that summer, Caucasian patrons stayed away except for young men hungry for jazz and young women studying sensual dancing they might introduce to white cafés.

As usual, Mayor Thompson was not paying attention to city problems. He needed former embezzling state treasurer Len Small in the governor's mansion so badly that he campaigned for him around the state, even though Thompson no longer had party backing. Through ghost voting, multiple voting and the usual polling place skullduggery, Small squeaked through the Republican primary. At the end of a politically tainted hearing on the irregularities, the Illinois Election Board let him stay on the ballot.

THE POLICE HEIST

That first autumn of Prohibition saw the most incredible heist in Chicago history. A consortium of saloonkeepers and speakeasy investors paid brothel keeper Mike Heitler—called "da Pike," apparently for being a piker—$175,000 for more than 1,200 cases of "medicinal" Old Grand Dad bourbon. His minions put the shipment on a parade of trucks at a South Side rail yard, each rig guarded by at least two Chicago policemen. Under Heitler's plan, the trucks left several minutes apart, supposedly to avoid drawing attention.

En route, nearly every isolated truck was stopped by other crooked policemen. Either Heitler was pulling a massive double cross on his customers, or according to rumor, a serial hijacking had been organized by "dirty" Detective Sergeant Edward Smale and word of the operation spread through the department. Saloonkeeper Frank Miller rode in one of the trucks to protect his investment after being released on bond for the Pullman mail bag robbery. He complained that "the coppers stuck me up," taking more than $2,000 in diamond jewelry as well as his share of the bourbon.

When nine policemen stopped another truck in the caravan on their own, officers guarding inside shot it out with them and ran a street roadblock, but no one was reported hurt. Next, two motorcycle officers blocked the nine freelancing robber-officers and then gave that truck and the next one safe

conduct for a payoff of $400 each. This made at least *three* sets of criminal policeman in one night.

Not one of the fifty-four officers believed involved filed a report. Shipment organizer Billy Truesdale could have told a grand jury a lot about the debased department. But instead of questioning him, officers took Truesdale to a city hall interrogation room and savagely beat him. When Chief of Detectives James Mooney was told about the assault on the floor above him, he replied that other policemen would tend to the matter and, a newspaper said, "refused to take a hand." Superintendent Garrity shrugged off the liquor robbery, double cross, gunfight between officers and beating of a major witness because, according to the *Chicago Tribune*, "he couldn't find any dependable police to carry out the investigation." Heitler's statements to investigators disappeared just after reporters learned of them, allowing Garrity to deny that Mike "de Pike" had said anything. The superintendent added that he would rather catch one robber than help federal agents.[16] Under public outcry, Heitler was convicted of conspiracy, fined $10,000 and sent to prison for eighteen months.

Drinking in general was far less solitary than a year before, with Prohibition bringing large numbers of men and women together for a few hours of fun. A tangible way to notice the consequences was a 25 percent increase in Chicago traffic deaths in Prohibition's first year, many no doubt resulting from drunken walking or driving.

Mayor Thompson's vote-stealing machinery saw to it that Small, Crowe and Eller were elected on November 2, 1920. When Big Bill heard that his entire three-man slate had won, he supposedly exclaimed, "The roof's off!"[17] New state's attorney Crowe would soon be given a personal detail of forty policemen, headed by disreputable former private investigator Ben Newmark, to conduct whatever investigations he felt like. In time, the detail would be called "Ali Baba and the Forty Thieves."

Considering the city's later history, it seems odd that so few of what the Chicago Crime Commission considered "gangland murders" occurred in the first year. These were homicides involving career criminals as victims or perpetrators. The count in 1920 was twenty-seven, Enright and Colosimo among them.

1921–1923

E arly into the new year, federal agents rounded up fifteen members of a New York–Chicago ring using forged government permits to take liquor from warehouses. The strong drink would be sold to wholesalers and druggists for four dollars a gallon. Believed the largest alcohol ring in the country, its members were said to include several unnamed members of Congress.[18] Pretending to be shocked at the rising crime, Mayor Thompson replaced do-nothing Superintendent Garrity with a good man utterly without police experience, his own secretary. At thirty-six, former newsman Charles Fitzmorris was the youngest chief in the city's history. The only reasonable explanation for his elevation seems that Thompson wanted a figurehead who was unaware of all the graft going on.

There was no actual police headquarters in 1921, although the superintendent's office and some interrogation rooms were in city hall. The real police work was conducted a short distance away in the detective bureau, a crumbling Loop building at 175 North LaSalle Street. Witnesses were routinely taken to a warren of small offices and questioned under the glare of calcium lights. Rather than being trained investigators, promising officers assigned to "the Bureau" could be sent back in uniform to a district (precinct) station for any reason. The police strength of just over five thousand officers for day and night protection of nearly three million was the lowest in the country, and their small pay in a time of prosperity was an inducement to demand payoffs.

Entrance bribery for this time is unavailable, but from 1925 to 1929 the administration took between $100 and $500 before accepting any police

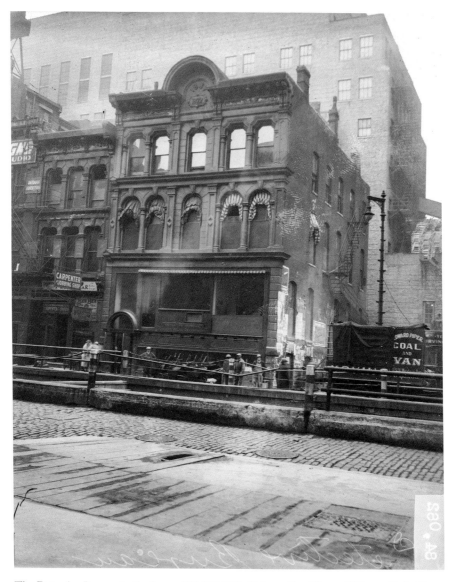

The Detective Bureau in the Loop. *DN-0084082*, Chicago Sun-Times/Chicago Daily News *collection, Chicago Historical Society.*

applicant, the amount determined by the number of openings. Some of the money went to the supposedly unapproachable police board. All three civil service commissioners took bribes, including Bishop Archibald Carey of the African Methodist Episcopal Church. He would be indicted but die of natural causes before trial. Officers were hired without background

checks, and the only education requirement seems to have been their ability to speak English. One lieutenant is said to have been unable to read sufficiently to call the roll.

Evidence was commonly spoiled, as it was handled by beat officers and reporters, and in important cases, the evidence disappeared. Essentially, the men in blue were taught just crowd control and making arrests in fights. Early in the 1920s, beat officers could be cowardly because they had little experience acting on their own, though training would improve by the middle of the decade. There was little need for investigations when information could be beaten out of witnesses and accomplices. A federal study noted that only wealthy prisoners avoided brutality, and Chicago police techniques "include applications of the rubber hose to the back; kicks in the shins; beating the shins with a club, and blows struck on the side of the head with a telephone book." Handcuffed prisoners were sometimes suspended upside down or subjected to tear gas.[19]

Superintendents were frequently chosen for their willingness to go along with the administration, such as allowing casinos and brothels to stay open. A holdover from the nineteenth century was that captains held more power than the superintendent, a strawman to be fired for the mayor's mistakes. The frequent bribing, beating and killing of witnesses suggests that some police captains kept criminals informed about investigations.

AMERICA'S WORST GOVERNOR

In the absence of a parole board, Governor Len Small began selling pardons soon after taking office in January 1921. Most convicts buying freedom appear to have been Chicago felons from Joliet State Prison. As the air rained pardons, Illinois attorney general Ed Brundage initiated a campaign to oust the new governor because of his felonious past. Insiders knew that Small had used loopholes to pocket $200,000 as state treasurer in 1905–7 by keeping the interest on state deposits. When he returned to the lucrative post in 1917, Small "forgot" to turn over the mounting interest for a year and a half and set up a dummy bank whose sole purpose was to funnel public money into major loans for legitimate businesses.

Brundage alleged that Small had personal reasons—hinting at a bribe—for vetoing funds to enforce a state liquor law that was more restrictive than the Volstead Act. In retaliation, Small held a July 4 news conference to charge that Brundage would use the $700,000 appropriation for himself.

The attorney general reacted by setting up a grand jury to investigate Small's practices as state treasurer, but the governor crimped its funding. When Brundage filed a suit against him, Small killed a $75,000 appropriation for seeing it through.[20] The state later came up with the money anyway, eventually leading to Small's indictment.

Enter Al Capone

Chicago history turned a corner in 1921 when gangster John Torrio contacted twenty-two-year-old Alphonse Capone, whom he had known in New York, about being a bouncer at his headquarters. My father always referred to the Four Deuces with wistful memory. He had known the place as a cab driver and then a chauffeur in a small bootleg gang. Capone would claim he arrived with just forty dollars in his pocket. Though only a little heavy then, Al gave a menacing appearance with his thick eyebrows, thick lips and a knife scar across his cheek.

Nascent beer outfits sprouting up around the city never began with someone telling friends "Let's start a gang." Each had a specific origin. For Torrio, it was eliminating Colosimo in 1920 to extend Big Jim's criminal network to bootlegging; Dean O'Banion took Charles Reiser's safecracker gang on whiskey heists; Terry Druggan and Frank Lake found themselves heading a gang when their mentor "Paddy the Bear" Ryan was killed; and the Genna gang was constructed around a hierarchy of six brothers. Any gang's strength depended on how much protection it could buy from the police, city hall and the courts.

Congressmen complacent about hijackings tried to hound federal judge Kenesaw Mountain Landis off the bench for his unbending attitude toward Chicago liquor violators. After he sentenced saloonkeeper Philip Grossman to a year in jail, requests for a presidential pardon came from the head of the Cook County Republican Party, the treasurer of the Republican National Committee and both U.S. senators from Illinois, William B. McKinley and Medill McCormick of the *Chicago Tribune* family. President Harding rejected their self-serving appeals.

Another person clinging to old-fashioned values was Police Lieutenant William Schoemacher, a dumpy man in a wrinkled suit. His common-sense approach to law enforcement could be seen in an arrest for a $500,000 securities theft from a downtown train station in January 1921. After brothers James and Thomas Shupel escaped capture in a rooftop shootout a few days

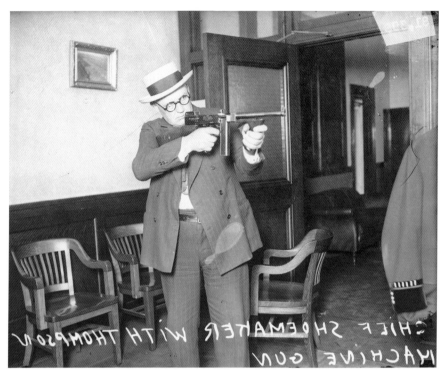

Lieutenant Chief William Shoemaker demonstrating a powerful new weapon, a tommy gun. *DN-0082619*, Chicago Sun-Times/Chicago Daily News *collection, Chicago History Museum.*

later, Schoemacher believed that James would stay close to friends. Rather than casting a dragnet or mounting a raid based on guesses, Schoemacher led four officers on a streetcar to check places the robber frequented. Noticing James on the street, they jumped off and took him to the detective bureau.

"THE BLOODY NINETEENTH"

The war over the ethnically changing Nineteenth Ward resumed in February when a bomb from Alderman John Powers's camp seriously injured five people at a rally for ward committeeman Anthony D'Andrea, now trying to unseat him. Eleven days later, the home of a D'Andrea political aid was bombed, and before long so was the challenger's headquarters. No such violence occurred among Sicilians in other parts of the city.

Irishman Powers must not have realized the risk he had taken in meeting bomb with bomb. Besides being backed by the Gennas' gunmen, D'Andrea

had just taken over the hodcarriers union after someone—perhaps from another faction—shot its president to death. D'Andrea also had support from thousands of people making raw alcohol for the Gennas. Four hundred policemen were dispatched to ward polling places in February, resulting in fifty arrests.

After D'Andrea's defeat, the Gennas began killing off their enemies, some for feeding information to Powers. A shopkeeper was shot five times in the back, a man was ambushed and another was shot and pushed out of a car. At least one of the killers may have been imported from Sicily. The gunmen in most of these attacks followed the Sicilian tradition of firing a shotgun as soon as they saw their target, to make sure they were the first to shoot and to have a fast escape. In March, Powers offered $2,500 for information in the killings, and the next night, Police Superintendent Fitzmorris transferred all 712 patrolmen, sergeants, captains and commanders in the two districts of the Nineteenth Ward, perhaps the largest mass reassignment in department history. But the shakeup did nothing to reduce the Genna-Powers ferocity. In April, a Genna assassin fatally shot Powers man John Mahoney in a West Side alley, finally ending the political war over the "Bloody Nineteenth." But now that D'Andrea was of no use to the brothers, his small political organization seemed a potential threat.

Now that gambling lord Jim O'Leary of the Chicago Fire family was being prosecuted with Mike "de Pike" Heitler for the liquor convoy robberies of 1920, rivals found him vulnerable. When Ben Newmark's forty state's attorney's raiders smashed into O'Leary's casino at 41st and Halsted, thirty men tried to jump through windows or climb down cables. Evidence would show that Newmark had made the raid at the behest of O'Leary's competitors.

Multiple brewery operator Terry Druggan was riding an auto when it was rammed by another car on the West Side in February. An occupant from each vehicle leaped out and kept firing and reloading, wounding a gangster and a female passerby before the autos drove off. Beer from Druggan's plants and others was being hauled daily in open trucks down arterial streets as speakeasies sprang up in every neighborhood.

Some were just enlarged restaurants with oilcloth-covered tables arranged around a small dancing area. A few "speaks" were being constructed as hidden rooms within commercial buildings, and a few still exist. Others were fashioned from office suites in downtown skyscrapers. Among the more elaborate places was the Club Arlington on North Avenue, protected by a peephole, steel doors and buzzers. Numerous mirrors let bouncers keep an

Frank Lake and Terry Druggan ran a bootleg gang generally without violence and inspired the film *Public Enemy. DN-0079320,* Chicago Sun-Times/Chicago Daily News *collection, Chicago History Museum.*

eye on patrons. In some speakeasies the management studied people walking in and gestured if they should be turned back as possible troublemakers. A few places frisked customers for weapons, and all recognized members of rival gangs were seated as far apart as possible.

Although the word *speakeasy* apparently came from "Joe sent me" whispers, not all entrance doors had eyeholes, especially those on upper floors. "Speaks" did most of their business on weekends, keeping white college jazz bands busy at places that barred Black musicians. Even speaks were part of the city's political machinations. Sociologist Robert M. Lombardo said that unlike other cities, in Mayor Thompson's Chicago, "the leading clubs in which famous ragtime and jazz musicians played were owned and/ or managed by black Republican Party organizers, who used the music to attract the attention of black voters."[21]

Whether run by white or Black owners, places that did not stock liquor usually allowed customers to bring bottles and pocket flasks. Some of these cabarets were tame, such as the Coconut Grove on 63rd Street. Customers included college students and a few patrons as young as fourteen, all hoping

for "a wow of an evening" in which they could look sophisticated for under two dollars. Nightlife reporter Sally O'Brien found such speaks friendly instead of dangerous, with music that was danceable rather than jolting, and even the scattered kissing and petting were mild.[22]

Businessmen and people celebrating birthdays or promotions were more likely to frequent places such as a downtown basement speakeasy called the Samovar. There O'Brien saw a young woman vomit from drinking and heard a boisterous woman saying as she put a towel over her dress to absorb any spilled alcohol: "We'll have liquid face cream to drink, and *how*, and *how*, and *how*!" Gangster patronage helped Colosimo's restaurant thrive as a nightclub a year after Big Jim's murder. O'Brien saw that each table had someone in charge of pouring liquor purchased elsewhere into tall glasses of shaved ice the house provided for a charge. Some bottles lacked labels, a sure sign of "hooch." Like many other nightspots, Colosimo's stayed open to 7:00 a.m.[23]

People wanting to know where to have a good time often asked cab drivers. Cabbies pretended to know all the speakeasies and brothels in town but received a commission for steering patrons to certain ones. Visitors to the city also found that hotel bellboys could provide anything from liquor to women, and some of the larger employers maintained private clubs so executives could drink without fear of raids.

Fearing that the Harding administration might send federal troops to guard mail trains, gawky labor terrorist Big Tim Murphy sped up plans for raising money after his arrest in the 1920 Pullman Bank mail bag heist. He told a postal clerk at the downtown Dearborn Street train station, "Come along with me and give me a tip…and I'll lay $10,000 on the desk in front of you." In April, Murphy and two others lined up a dozen postal clerks and mail drivers at the station loading platform and took more than $300,000 in checks and securities. The clerk talked, and Judge Landis—looking like a biblical prophet—sentenced Murphy to the maximum of six years in prison.

THE "BLOODY NINETEENTH" AFTERMATH

A short time after the Mahoney killing, Anthony D'Andrea's landlord received a letter saying the West Side building was about to be blown up. D'Andrea disregarded the warning, but he and his wife left so decorators could paint their first-floor apartment. Two Genna gunmen entered through the basement and crept up a narrow stairway. Reconstructing their

movements from smudges and other evidence, police believed the men had nudged open a front window and crouched in wait until D'Andrea left a car driven by his bodyguard Joseph Laspasia. After several shots, Anthony fell dying and the killers took off.[24] But the takedown of his organization was not yet complete.

Laspasia was driving three men he trusted through the neighborhood in late June, unaware that his passengers were Genna men about to kill him in a method not yet termed a "one way ride." A backseat passenger hunched over and blew away the back of Laspasia's head as someone in front grabbed the wheel and stopped the car in front of a church. Pastor Louis Gianbastini interrupted a service and pushed through onlookers to give absolution to the man dying over the steering wheel. Infuriated when no one would answer police questions, the priest said in Italian, "I am ashamed of you. Children, you tell what you know. Don't be afraid of your elders."

With Powers cowed and the Gennas now unchallenged in Little Italy, the only way an outsider could command the huge raw-alcohol factory that the Near West Side had become was through the Unione Siciliana. Only the main chapter in Chicago and a loosely run unit headed by Frankie Yale in New York remained active. The organization had been incorporated a quarter of a century earlier by several Italian businessmen at a time when immigrants were commonly discriminated against. Eventually, the Unione was corrupted through infiltration by Black Handers who used its personal data to find extortion targets.

There also was an eruption of bombings by bootleggers, labor racketeers and people wanting to confine African Americans to the Near South Side black belt. A prisoner told police about a "bomb trust" that made black powder and dynamite packages on consignment. The price ran up to one hundred dollars per job if someone was needed to light and throw the bomb.[25] Most packs consisted of dynamite sticks bound together, but the bundles were called "pineapples" because they were tossed like military shrapnel grenades.

Some of the liquor thefts were outrageous. Terry Druggan's gang of young men recruited from the Irish neighborhood obtained a duplicate key to remove four barrels of medicinal alcohol, including whiskey, from a supply room at West Side Hospital. Someone withdrew numerous other whiskey cases from the evidence vault in the Criminal Court Building on the Near North Side. No one reported the theft for eight years.

Yet there was still no major North Side bootleg gang. Career burglar Charles Reiser kept Earl "Hymie" Weiss and five-foot-four Dean O'Banion

working on lucrative break-ins, often with information from well-informed contacts. A night watchman heard the gang cutting into a safe at a downtown office in May and ran to fetch a policeman. Sergeant John Ryan arrested all four just after they had nitroglycerined a safe and burned some of its $35,000 contents.

With the Gennas systematically killing anyone close to D'Andrea or who might want to lead the Unione, retired plasterer Joseph Sinacola took it upon himself to guard the D'Andrea family. The old man was speaking to a six-year-old boy in July when a gunman climbed out of a car, wounded Sinacola and sprinted down the sidewalk. He recovered and was released, but no one really escaped death in Little Italy. In August 1921, Sinacola was shot to death in a rocking chair as the same boy and his thirteen-year-old daughter watched in horror. This was at least the thirteenth killing over the "bloody Nineteenth."

Also that month, Governor Small was indicted for stealing half a million dollars as state treasurer, but that did not keep him from selling pardons. A person representing the governor, or someone acting on behalf of Mayor Thompson or State's Attorney Crowe, would offer inmates a passport to freedom for a price set by the circumstances.[26] One imagines the factors included the prisoner's ability to pay, his eagerness to be released and the difficulties in making the action appear legal. Among those obtaining a pardon was middle-aged killer Walter Stevens, locked up for wounding an Aurora policeman. In return for his freedom, Stevens helped fix Small's upcoming trial.

On the month of the governor's indictment, authorities disclosed how a Chicago ring smuggled Canadian whiskey to clientele listed in the Social Register. A Dr. Blackmer introduced suave bootlegger James Walsh to fellow members of the Illinois Athletic Club, and Walsh then joined the South Shore and Chicago Athletic Clubs for additional clients. Nationally known humor columnist George Ade paid him the Prohibition price of $170 a case.

Federal agents seized a Walsh shipment from Detroit, but he and his wife disappeared after bribing them with $21,000 in cash and $14,000 in furs. For some reason, the entire "archives" of the case, including notations on hundreds of transactions between Walsh and what papers called "well-known Chicagoans," were placed in the home of Judge William Gammill, who was leasing his apartment from Walsh. The papers vanished on their way to the federal building.

Unlike the bloodshed in Little Italy, 1921 saw only a few killings among bootleggers. But for robbing some gang's liquor shipment, "Big Steve"

Wisniewski was forced into a car in July, shot repeatedly and his body shoved out in the far north suburbs. In talking about the murder, up-and-coming mobster Earl J. "Hymie" Weiss coined the phrase "He was taken for a ride."

The times were so lunatic that no public outcry erupted when the State's Attorney's Office in Chicago mishandled its biggest case in years, the eight White Sox players accused of throwing the 1919 World Series. One ball player turned state's evidence, but under Crowe, grand jury documents and all three confessions disappeared, as well as papers pertaining to New York gambler Arnold Rothstein and Sox owner Charles Comiskey. With the evidence taken, the athletes and gamblers charged were found innocent in August after less than three hours' deliberation.

Chicago may have been beyond reform by then, but major-league owners needed to bring disgusted fans back. Of all the honest people in the United States, they picked white-haired Judge Kenesaw Mountain Landis from the federal court in Chicago as the game's first baseball commissioner. Several congressmen who may have been friendly with criminals used this new side job as a way of forcing Landis into hanging up his robe. The court missed his crusading spirit and colorful eccentricity. The city had clearly been overtaken by a mentality that anything facilitating the freedom of drinking was permissible: judges were hounded for upholding justice, shotgun blasts were tearing up Little Italy, bootleg gangs were nurturing political connections and Governor Small was unlocking prison cells. Then on June 1, 1921, hate came to town.

Ku Klux Klan Great Lakes director C.W. Love arrived from KKK-controlled Indiana and, like a spider, went about building webs of discord in overlooked corners. Just a month earlier, the Chicago Real Estate Board, in a white backlash to Thompson's courting Black support, agreed to expel any member selling or leasing property to African Americans outside the Second and Third Ward black belt along State Street.

The northern advance of the Klan was part of organizer D.C. Stephenson's plan to win the White House. Since Thompson was protecting the Black vote, Stephenson's strategy for Chicago was to generate hostility against Catholics and the foreign born, leaving racial hatred unspoken rather than undermine the mayor's office. Presenting the Klan as a fraternal organization, C.W. Love opened a downtown office in the name of the Southern Publicity Bureau, sold memberships for $10 and charged $6.50 for a standard white robe and $7.50 for one custom made. Next, the Invisible Empire became startlingly visible with a full-page *Chicago Tribune*

ad on August 6 for "All Lovers of Law, Order, Peace and Justice." That night, 10,000 Klansmen and 2,300 recruits rallied outside suburban Lake Zurich. By wavering torchlight, the initiates kissed the American flag on bent knee. Days later, an alderman and a judge praised the Klan as a solution to lawlessness, and the *Tribune* gave the Klan fawning coverage until the paper received letters of outrage. Soon one Chicago Klan unit accepted only businessmen, and another admitted just lawyers.[27]

At the same time, bootlegging was swelling the labor pool of thugs, gunmen and officers on the take. After suspending a police lieutenant for helping Hymie Weiss steal a railroad shipment, Superintendent Fitzmorris told U.S. District Attorney Charles Clyne and Deputy Police Superintendent John Alcock that "50 percent of the police department"— amounting to more than 2,500 officers—"is interested in some way in violating the prohibition laws." A woman testified in late September that a policeman tried to shake down two African American rumrunners—a generic term for bootleggers—for $1,000.[28]

Ordinary citizens had nothing to fear, but the streets were no longer safe for anyone carrying a sizable sum. About fifty thugs offered themselves as bodyguards for gamblers bringing winnings to safe deposit boxes. Some of these men may have then sold tips to Charles Reiser and his North Side thieves. With two watchmen tied up apparently willingly in the West Side Masonic Temple, the gang removed nearly $87,000 from its supposedly burglar-proof basement vault.

When Reiser's wife noticed a car parked outside their flat in October, Charles grabbed a pistol and went out to confront the occupants. They severely wounded him, possibly for looting a strong box he should have left alone. Doctors at Alexian Hospital told "Mrs. Hope" that her husband was permanently paralyzed. When she visited him, he asked her to bring a gun next time. A week after his wounding, hospital workers heard three shots and found part of Reiser's head blown away. Mrs. Reiser gave up the pistol and was never brought to trial. Hotheaded Dean O'Banion took over and led the safeblowers into the alcohol trade full time.

Mayor Thompson's lack of political leadership whetted State's Attorney Crowe's mayoral appetite. Pretending to be a crusader, the head prosecutor fired chief investigator Ben Newmark and cracked down on brothels and casinos for a while. But mail robberies were so frequent that U.S. Marines started guarding trains between Boston and Chicago, and troops were assigned to Chicago's federal building, U.S. Customs House, Federal Reserve Bank and neighborhood post offices.

Newmark soon found a job as the liaison between gangsters and Mayor Thompson's chief city attorney, Samuel Ettleson, who ran Chicago during Big Bill's apparent drinking binges. The real city hall was a suite in the Hotel Sherman, where Thompson would lie on a couch while his patronage chief and chief manipulator Fred Lundin worked a box of contact cards. Anyone in the rackets could be called on for a donation or a favor.

Besides politics, there were numerous ways of legally profiting from the burgeoning alcohol business: carpenters and plasterers remodeled places into speakeasies, tailors sewed special gun pockets into suits, gold diggers (seductive young women) sidled up to gangsters and hatcheck girls traded smiles for large tips. Female reporters charmed gunmen for information that male reporters could not pry out of them, the Congress Hotel gave them suites and sporting goods clerks sold them shotguns. A Buick dealer was rumored to be flattering gangsters and giving them test drives in hope of turning his cars into status symbols.

People were involved in so many rackets at least part time or occasionally that anyone might become a target. Flamboyant young defense attorney William W. O'Brien, usually seen in a flattering suit and with a large cigar, was shot twice in a knock-down fight with a labor terrorist in a 59th Street thieves' hangout and gambling place. By refusing to name his assailant, the *Chicago Tribune* informs us, "he won plenty of business from mobsters after that." O'Brien would narrowly escape death in the Hymie Weiss ambush and inspire the flashy amoral shyster Billy Flynn in the play and musical *Chicago*.

Commonplace-seeming Democratic alderman Anton Cermak nudged his way to head of the city hall's "wet" faction so that slatemakers might regard him as a challenger to Republican Thompson. Cermak was the eldest of six brothers and sisters from what is now the Czech Republic and functioned best when in charge. Despite a limited education, he could see possible developments well in advance. The little man used his booming voice to make up for his chunky appearance and formed alliances by telling white ethnic groups what they wanted to hear.

As the holidays neared in late 1921, adulterated liquor led to a citywide increase in acute alcoholism, with more than half the patients strapped to their beds.[29] Such reports increased the demand for the supposed real thing. Bootleggers paid railroad clerks up to $500 for tips on $15,000 shipments of disguised uncut Canadian whiskey, and New Orleans dock workers stacked a weekly average of three hundred cases of Bermudian hard liquor onto Chicago-bound Illinois Central trains.

If a gangster purchased a truckload of three hundred pints, he usually paid $2 apiece. Pints were preferred because they easily fit specially built compartments at the bottom of six-seat touring cars. Unless their destination was the North Side Gold Coast or the exclusive South Shore neighborhood, they were taken to a cutting plant. There the three hundred pints would be combined with water and perhaps cheap ingredients to make up to nine hundred pints of "sozzle" disguised with counterfeit distillery labels and revenue stamps. After giving around $1,500 to Prohibition agents for letting a vehicle through, the bootlegger sold the watered-down pints for $7 each.[30]

When legal cabarets and nightclubs opened for New Year's Eve parties that year, they were watched over by a total of five thousand policemen and federal agents. And so ended the last relatively quiet year of the Prohibition period, with only twenty-nine gangland murders despite the Nineteenth Ward slaughter. The public did not yet perceive bootleggers as heartless criminals. Rather, customers "looked on beer runners as heroes," reporter James Doherty recalled, "they were risking life, limb, and liberty" to meet a demand and spread cheer in the most hedonistic times since ancient Rome.[31]

Women had been given the vote in 1920, and in the disconnectedness of the times, many found an energy and identity their mothers could not understand. Though females had once been held up as examples of proper behavior, many girls of high school and college age longed for nightclub exhilaration, egged their boyfriends on to drive faster and sometimes encouraged them to strike a man for an insult. A woman checking into a hotel might be concealing her date's gun in her purse. Much of the freedom they flaunted came from their economic independence. For the first time, thousands lured from farms and small towns were working in Chicago as secretaries, switchboard operators, waitresses, elevator operators and department store clerks. Many other young women clung to their moral values, and some tamed their wild boyfriends or at least persuaded them to do the right thing when trouble occurred.

Speaks generally turned away lone women to avoid trouble, but girls tended to drink at tables with friends or on dates. Hard drinking was now socially expected for executives and salesmen. Some Loop companies set up basements or upstairs areas for selling liquor, and a few hotels found that offering special rooms for drinking was good for business. Poet and local attorney Edgar Lee Masters observed that "Cynical Chicago smiled" on such practices.

Much of this secretive business citywide was based on raw alcohol manufactured in the Near West Side. The Genna brothers gave Sicilian

immigrants ten to fifteen dollars a day to distill alcohol in their shabby flats. Grandparents often tended to the equipment and returned to their rocking chairs while others in the household worked regular jobs. Women stirred the mixture with brooms and checked siphon hoses going from mash barrels to the cookers. With occasional watching, the copper kettle of a home distiller produced 350 gallons a week at an average cost of seventy-five cents a gallon.

After adding caramel coloring and fusel oil, the Gennas sold the results to gangsters for whatever the market would bear, two to six dollars a gallon.[32] Distributors had this rough product redistilled to remove obvious contaminants, including rodents, metal shavings, wood chips and whatever dirt and family garbage the brooms had picked up. So many relatives were involved that few people helped authorities when someone was beaten or shot, as in today's drug culture.

You could smell the alcohol distilling in apartment corridors just a brisk walk from downtown and in the streets as well when windows were open in summer. The work kept on despite reports of flats blowing up from the use of natural gas in distilling. Meter readers detecting a telltale rise in usage sometimes "put the shake" on customers. So the Gennas taught people how to divert the gas, but a few died as they tapped mains under sidewalks. The gang reportedly removed the bodies quickly and had its own physicians attribute the deaths to natural causes.

With flavorings, the ersatz whiskey, scotch or bourbon was sold to neighborhood speakeasies. Operators usually watered down the already-diluted liquid to half strength. From two gallons they could sell 192 drinks at a quarter apiece, which was why speakeasies proliferated and social drinking was encouraged. With so much adulteration, a certain amount of inebriation was psychological. Confiscated records would show that the Gennas kept more than three hundred Chicago policemen on their payroll.[33] To maintain an area-wide supply of raw alcohol, fashion-conscious Genna assassin Sam Ammatuna supervised sugar sales to home distillers in the corrupted suburbs of Melrose Park, Cicero and Chicago Heights.

President Harding called the lax monitoring of Prohibition under the Anti-Saloon League–endorsed Commissioner Roy Haynes a national scandal. When Harding died the next year, Haynes reportedly told the head of the New England branch of the League, Arthur Davis, to keep the new president, Vermonter Calvin Coolidge, in line. Haynes is also believed to have had a hand in the appointment of several ineffectual federal judges in Chicago and elsewhere.

With fewer trucks hauling authorized medicinal and sacramental liquor shipments, and deliveries better guarded, robbers had found other places to plunder by 1922. In January, five bogus policemen stole whiskey cases from a downtown commercial loft. Any bootlegger with intelligence and ambition could rise quickly in these fast-moving times. Al Capone was doing so well as John Torrio's lieutenant that sometime in 1922 he invited his older brother Ralph to relocate from New York. The rest of the family would settle in Chicago's South Side the next year. Lacking Al's drive, Ralph would be content with running a maverick brewery and a small Cicero speakeasy.

The head of the moribund Cook County Democratic Party, portly George Brennan, looked around for someone to defeat Thompson the next year, and Judge William Dever stood out amid the general moral decay. The Irish conservative Catholic had been an independent alderman before his election to the Illinois Superior Court. Though incapable of grasping the long run, Dever had a professorial manner and tidy appearance. With his two-mindedness about Prohibition, he was supported by both "wets" and "drys." He chose as his only campaign platform to "put an end to crime, lawlessness and bestiality" (meaning brutality).

Bootleg tactics such as beatings and bombings were now standard in union takeovers. Bombers from a construction trades union fatally shot a policeman trying to arrest them, and the next day the same men killed an officer trying to stop their car. Evidence led to the arrest of Big Tim Murphy, who was attempting to stay out of prison after his conviction for the Pullman Bank mail bag robbery.

As Governor Small faced an embezzlement trial in central Illinois, his lawyers twice cited an antiquated British tradition that "the king can do no wrong." Small received bags of letters praising his character from state workers and state contractors, with state-paid postage and state trucks speeding up the mail. In addition, men from Torrio's South Side gang and Dean O'Banion's North Side outfit went about showing potential jurors photos from when Small was an innocent-looking farmer and Kankakee banker. Mobsters such as assassin Walter Stevens next threatened any impaneled juror not already bribed with cash or a state job guarantee. In June 1922, the jury found the governor innocent on the grounds that prosecutors had failed to show how he profited from his creative bookkeeping. Small soon welcomed support from Thompson, racketeers and the KKK for his second term.[34]

Needing to expand the North Side gang, Dean O'Banion began by taking on car thief Vincent "Schemer" Drucci, perhaps the bravest of Prohibition

mobsters. Neither O'Banion nor Hymie Weiss was good at business, so next they brought in Samuel "Nails" Morton of the black-and-tan shootout. O'Banion then picked up thug Maxie Eisen, transplanted cowboy Louis Alterie and finally the burglary brothers Peter and Frank Gusenberg. The South Siders derisively called these men "the Irishers," even though they were of Welsh Irish, Polish, Italian, French Spanish and German Jewish descent, forming the most flexible, creative and ethnically diverse outfit in the city.

Brewery lord Terry Druggan was now a man about town living in the swank Parkway Hotel on Lincoln Park West, but from his shanty years he craved excitement. In June 1922, he and an acquaintance stole more than $11,000 in jewels from two attractive society women. Druggan was acquitted with the help of Clarence Darrow, who was among the young attorneys building careers on jury tampering and other common illegalities.

The northern Klan had become arrogant with its lightning success in Chicago, and a handful of good men decided to weaken its grip. Robert Shepherd, Joseph Keller and Grady Rutledge formed the American Unity League, with Black Episcopal bishop Samuel Fellows as honorary chairman. The driving force was attorney Patrick H. O'Donnell. Having grown up in Indiana, he well knew how the Klan could engulf a state but that dissatisfaction within the ranks could always be exploited. A former recruiter offered to sell the League the names of six thousand members for three dollars apiece. When he turned down a lower figure, the Unity Leaguers set him up with a stack of money in their downtown office. They said his list could have been copied from a phone book, and they wanted to compare it with a (nonexistent) partial one they had.

One of the league members raced to a nearby office and locked the names in a safe, forcing the turncoat to accept the smaller sum on the table. Lists of Chicago Klan members and their occupations were published in successive issues of the league's *Tolerance*, sold at newspaper stands and available in countless churches. The exposure led to sanctioned boycotts of Klan businesses and unsanctioned bombings at its printing press, and within a year, the hate movement in Chicago was a receding tide.[35]

In November 1922, voters chose Alderman Anton Cermak for county board president and Coroner Peter Hoffman as sheriff. The increasingly wealthy Cermak was soon steering county business toward his West Side real estate holdings while staying mum about crime. As for Hoffman, he was already on John Torrio's payroll and now made jail more comfortable for inmates willing to pay.

The city's most famous confidence man, dapper Joseph "Yellow Kid" Weil, whose career would inspire the film *The Sting*, was sentenced to five years for fleecing a banker out of $1,500. He grudgingly met Governor Small's asking price for a pardon and let his criminal contacts know how they too could buy themselves out of practically anything.

Many of the thirty-seven "gangland" murders in 1922 apparently derived from labor racketeering and personal quarrels. And all kinds of scams were going on. The lively Green Mill speakeasy on the North Side seemed ripe for squeezing before it became mob run. City revenue collector William Yaselli told manager Henry Horn he would be allowed to "run open" on New Year's Eve for $10,000. When Horn turned him down, the bogus count resorted to entrapment with the help of the Prohibition Bureau. Female agent Laura McCluskey threw a New Year's Eve "girls' booze party" and came with her own liquor as an excuse for shutting the place down. Horn was arrested amid holiday celebrations, but a federal judge denounced the government's complicity in extortion and acquitted him.

So it was that with the new year, police and federal agents were held in low regard, good people were using bombs and gangsters were socially popular. The times were expressed by a character in a 1923 film: "We're going to break all Ten Commandments and become rich and powerful." By then, estimates for the number of Chicago policemen involved in bootlegging, from mixing ingredients to looking the other way, had increased to 60 percent, and officers were letting at least fifteen illegal breweries keep daily operations. The gangs grew as the stakes rose, and for the first time anything—anything—could set off a bootleg war. Even a governor's pardon.

State's Attorney Robert Crowe continued to treat indictments as a yo-yo, casting them out for all to admire and then pulling them back when no one was looking. We do not know of any bribes he took, but his actions always sided with influential criminals who might sway elections for him and chosen candidates. The few mobsters sent to prison could rely on Governor Small's "pardon mill." Jumping ahead, by the end of his administration he had put his name on release papers for an incredible 950 felons, including gang killers. Approximately 40 percent of them are said to have joined Torrio's outfit, pointing to a conduit between the governor's mansion and the South Side gang.

Mayor William Hale Thompson, perhaps regretting his decision sit out the election, in March 1923 dispatched four hundred policemen to *guard* "vice resorts" from do-gooders.[36] Sheriff Peter Hoffman's malfeasance was

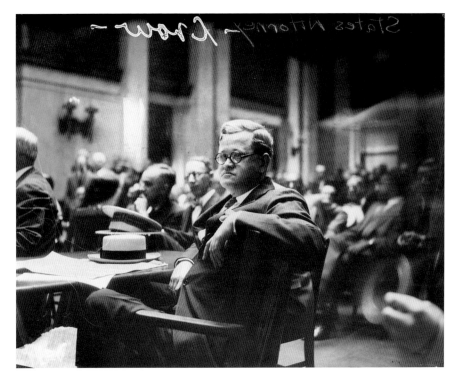

State's Attorney Robert Crowe, a gangster's best friend. *DN-0081254*, Chicago Sun-Times/ Chicago Daily News *collection, Chicago History Museum.*

such that three inmates told the city council's Health Committee that a city physician sold morphine to inmates for two dollars an injection. Dr. Ben Reitman, a people's advocate, testified that the city might have more than sixteen thousand drug addicts, some as young as ten. With so many liquor schemes going on, no steps were taken to combat the problem.

The biggest gangland disgrace concerned not Chicago but Gary, the young Indiana steelmaking city near the Illinois state line. Federal agents arrested Gary city judge William Dunn and wealthy defense attorney D.A. Lukas in September 1922 for leading an alcohol conspiracy involving more than sixty public employees. Mayor Roswell Johnson, Lake County sheriff William Olds and scores of liquor smugglers had thrashed out a plan whereby bootleggers were sworn in as deputy sheriffs and then taught established deputies the skills of transporting contraband.

Whenever liquor arrests were made, the prisoner was brought before Judge Dunn, and he would dismiss the charges. In addition, Dunn made defense attorneys special judges. Sometimes serving as a defense lawyer and

judge on the same day, they would dismiss each other's cases for a payoff. The system came to light when a sixteen-year-old girl excitedly told a friend about being allowed to drive a hooch truck. But the sensational disclosures came to nothing after the key witness, Gaspere Monti, was blown away with a shotgun on the steps of a Gary civic club in March 1923 following two earlier assassination attempts. Mayor Johnson would be reelected in 1930.[37]

Former judge Dever won the Chicago mayoral election in April, and his new police superintendent, Morgan Collins, started by giving the department the same mobility and firepower as gangsters. He replaced two-man squads in small "flivvers" with six-man flying squads that could roar out of station garages in unmarked, high-powered Cadillac touring cars equipped with rifle and shotgun racks.

But Dever was not a true reformer. Morgan's first orders were to clean up vice and petty crimes in interracial neighborhoods along the fringe of the black belt. Eight hundred men and women were jammed into police stations over five days as officers closed 4,000 Black-owned speakeasies and saloons as well as hundreds of cigar storefronts and a few private clubs. Collins then went after the 6,500 liquor-selling soft drink parlors citywide. He let murderous gangs alone.

For some reason, Chicago's bootleg gangs drifted more toward melodrama than in any other city, beginning with the death of Samuel "Nails" Morton. At twenty-nine, the North Side mob's financial advisor was one of the oldest and most experienced gangsters in the city. He lived in the Congress Hotel but took over the Schofield floral shop across from Holy Name Cathedral as a front and office. Once a week, Morton enjoyed talking with one friend or another as they rode trails in North Side Lincoln Park. But he lost control as he swung his bay parallel to Wellington Avenue on Sunday morning, May 13, 1923.

Possibly scared by traffic, the horse reared up and bolted onto Clark Street. When Morton locked his legs in the stirrups, a strap broke and he was pitched forward while gripping the reins. The skittish horse kicked him in the head as it galloped down the street, and Morton died in a hospital two hours later.

This first death of a Chicago bootleg leader must not go unpunished, according to a story apparently made up by the *Chicago Daily News* and later embellished by the *Chicago Tribune*. Shortly after Morton died, "Two Gun" Louis Alterie from out West supposedly gathered his friends and went to the stable. The story says they rented the horse and brought it to a large vacant lot, where they formed a firing squad and executed the animal. Alterie

allegedly returned to the stable and told the owner, "We taught that ——— horse of yours a lesson. If you want the saddle, go get it." Several details prove this a fabrication, such as that Nails had just bought the horse and did not rent it. In addition, flashy and shallow Alterie apparently was not in Morton's relatively classy circle of friends and was never known to initiate an action. But Alterie made a character colorful enough to fit a story so good it would highlight the 1931 Chicago-based film *Public Enemy*.

With Morton's death, no one was level-headed enough to mediate between gangs outside the Italian community, where Michele Merlo was still arbitrator. Even so, a truce was arranged by an unnamed financial backer who had millions invested in the alcohol market. This could have been Joseph Stenson, since he used both West Sider Terry Druggan and South Sider John Torrio as front men for rogue breweries.[38]

Stenson was far from the only entrepreneur profiting from Prohibition. Thirty food companies—some well known and most based in Chicago—conspired to shunt millions of gallons of specially denatured government alcohol to rumrunners across the country. Executives of Fleischmann Yeast of Ohio and the Corn Products Refining Company of suburban Chicago, nationally known maker of Argo corn starch, would be charged with keeping liquor gangs supplied with ingredients. After raiders broke up Joseph Peskin's South Side still, his food distribution firm linked to the Calumet Yeast Company of Chicago sold bootleggers enough corn sugar, malt and yeast to produce $8 million worth of alcohol in less than a year.

Officials believed you could buy liquor at twenty thousand locations in the city, two thousand of them speakeasies. Some were near high schools and colleges. In addition, federal agents in the summer of 1923 closed several licensed breweries for turning out real beer, including the Peter Hand company on the North Side and the Torrio/Stenson Puro Products company in what is now Calumet City. Employees helped gangsters rig thousands of feet of hose across rooftops to makeshift "bottling plants" where bottles of legal near beer were illegally injected with alcohol through the cork. The result was not the same as before, however. An early talkie has a man gulp down some beer, make a face and say, "I can still taste the needles." After Torrio pleaded guilty in December and was fined $2,500, he feared a second conviction would land him in prison.

Five boys from the Austin High School band on the Far West Side popularized Dixieland-style jazz, reflecting the hyperkinetic times. But older people found the brassy music too nervous. In June 1923, Erskine Tate brought his small interracial orchestra out of a black-belt movie

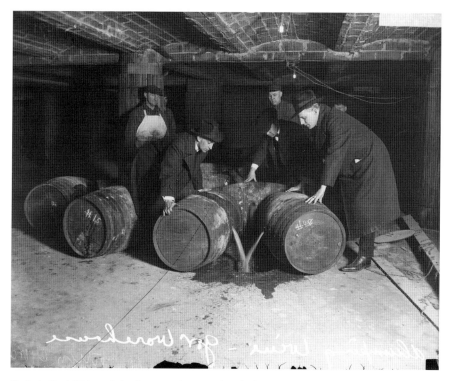

Early in Prohibition, federal agents dump casks of wine after a raid. *DN-0072930,* Chicago Daily News *collection, Chicago History Museum.*

theater and into a recording studio for early renditions of the big band sound, with Louis Armstrong on cornet, and some African American blues singers in this period performed for "race records" at Chicago studios. By the mid-1920s, King Oliver's nine-member band had carried the swing to respectable Chicago dining places. His men featured the novelties of derby hats and plunger ends as mutes for a tinnier sound.

During the 1923 gang truce, Torrio reached agreements with independents and mid-level mobsters like Martin Guilfoyle of the Northwest Side. Guilfoyle turned over a portion of his profits to Torrio, and Torrio made sure Marty was undisturbed by rivals and the police. Another handshake franchise went to Ralph Sheldon, who used Irish toughs to dominate the stockyards area in the New City part of the South Side, where many of the forty thousand workers drank after work.

We have just a glimpse of what life was like for bottom-rung bootleggers before all hell broke loose. Blue-collar worker Joseph Bucher told a reporter that the six O'Donnells paid him fifty dollars a week to back an empty truck

up to a heavily covered one arriving from the East between 10:00 p.m. and midnight, then drive his loaded rig to a South Side repair garage. Such low-level gang members usually worked at other jobs by day, either at legitimate businesses or pulling off burglaries or robberies, and they must have been tired and perhaps tipsy as they loaded and unloaded cases or barrels. They were not trusted enough to advance in the gang. But sluggers were another matter. Since some "muscling in" by a rival was tolerated except during beer wars, they may have received a commission for each saloon they converted rather than acting on orders from above.

The strain of the 1923 truce could be seen nightly as rival trucks were overturned, windows were smashed at thirty-five saloons buying from the wrong supplier and several men were slugged unconscious. This was definitely a bad time for the O'Donnells to work out a deal with Governor Small to cut short the bank robbery term of their tall and lean eldest brother, Edward. But first the governor asked for something to hang his hat on. So the brothers sent political fixer Sanford Rosenbaum to Springfield, the state capital. Five state senators and five state representatives quickly went through the charade of petitioning for "Spike's" release because he was an upstanding citizen who did not deserve his sentence of fourteen years.[39]

The Joliet prison gates opened in July after Edward O'Donnell had served just five months, and the re-formed family then shopped for a territory. Being a reasonable man, Torrio tried to arrange a deal with them. But the O'Donnells retained a hood mentality and shared the general Irish loathing for even former brothel keepers like him. The six brothers started to pound their way into the vast Torrio/Sheldon-controlled stockyards area, which through the early 1920s butchered more meat than anywhere else in the world. Here was where wealthy cattlemen stayed at expensive hotels while cowboys and workers from the rail pens to the killing floors drank elbow to elbow after work and on days off. In the face of the O'Donnell challenge, the Torrio/Sheldon gang reduced beer prices by ten dollars a barrel. When the brothers replied with force, Sheldon hired the most unstable of all Chicago gangsters, pudgy one-time car thief Frank McErlane. Everything was now in place for the start of the city's violent gangland era.

On Friday night, September 7, 1923, the O'Donnells shattered the "hair-trigger truce" by walking around looking for trouble. This led to a saloon fight near 53rd Street that ended when McErlane shot down O'Donnell man Jerry O'Connor at the door. Ten days later, the usually sober George Meegan of Spike's gang drank heavily to build up the courage "to get" McErlane. As soon as Meegan's car crossed the path of a Torrio/Sheldon auto, the

two sides traded an estimated fifty shots, killing drunken Meegan as well as O'Donnell man Joseph Bucher, who had recently spoken about being a beer truck driver. No one was convicted, but violence over the Meegan and Bucher killings would continue for years.

The day after the truce was smashed, federal officials called an unprecedented meeting with city and county authorities to curtail gang rivalries. Most of the changes were administrative, but at least Police Superintendent Collins put stalwart Lieutenant William Schoemacher in charge of gangland crimes. Then the police rounded up seven hundred people for questioning, compiling enough information to break up fifty stills and demote five police captains working with bootleggers. But Mayor Dever saw no advantage in cooperating with county and federal officials, and the push fell apart.

In mid-October, burglars broke into a North Side storage company with sledgehammers and acetylene torches before whacking the lock knobs off safe deposit boxes holding such valuables as $250,000 in securities. Storage officials were so busy apparently informing underworld customers about the break-in that they waited five days before notifying the police. Evidence suggested that stockbroker John Worthington had masterminded the job while serving a mail fraud sentence in federal prison. The head of the burglary team and his attractive wife were later shot to death after being followed to East St. Louis, Illinois, allegedly for his holding back some of the loot.

With millions rolling in from Little Italy's homemade raw alcohol production, the Gennas needed more room and kept more than one hundred barrels in a cellar near their headquarters, at 1022 West Taylor Street. At the maximum of 198 proof, each gallon brought $6. This was cut by others to a more drinkable 100 proof and sold in several bottles for $3 each. The police, working all their fingers, estimated that the gang must be grossing $350,000 a month. Although Little Italy was concentrated on the Near West Side, a small portion overlapped the traditional boundary for the Near North Side, pitting the systematic Gennas against jumpy Dean O'Banion. With Torrio's tacit approval, the Gennas now peddled their alcohol in the shared area, which included "Death Corner" at Oak and Milton (now Cleveland Avenue), where more than a dozen unrelated killings had occurred over the years and more would follow.

The supposed reform administration continued its long-standing practice of concealing information that would make the city look bad. So it was that a county grand jury said it could find no evidence of prostitution

anywhere in Chicago and exonerated police officers protecting the sex workers. In contrast, state's attorney's raiders five days later captured six women and fifty men at the Speedway Inn, one of two Torrio vice resorts straddling Burnham, Illinois, and Hammond, Indiana. During a raid, women would flee into the opposite state, but this time authorities were on to the trick.

Prohibition was so much a part of American culture by now that it inspired jokes, such as "Nowadays it is important to let one's tailor know whether you want pint or quart pockets." As with Chicago speakeasies, each suburban roadhouse had its own character. Some were fashioned out of former homes, providing upstairs bedrooms for hourly rent without registration or questions. Others were slammed together from plywood and beaverboard. The walls of the Lone Tree Inn near what is now Skokie were so thin they vibrated from nightly trumpets, drums and trombones. Reporter Sally O'Brien noticed shopgirls and stenographers there in their best clothes and their hair marcelled into tight waves like magazine ads. When one girl wanted to leave, her boyfriend ignored her and said, with a pint of gin in hand, "Mother, mother, close your doors, your son isn't coming home tonight."

"I don't want to go home," a woman said toward dawn, "I'm just starting to have a good time."[40]

In December 1923, vigilantes helped the police raid a roadhouse in suburban Plainfield where a sixteen-year-old girl had been raped reportedly by human traffickers. And so it was weekend after weekend at inns along every major road in Chicagoland. Yet the public was led to believe the criminal justice system was protecting them. In that year alone, Crowe plea-bargained or quietly withdrew *twenty-four thousand* felony charges while sending fewer than two thousand criminals to prison.[41]

Mayor Dever's crackdowns had the unintended consequence of raising the price of real beer to forty dollars a barrel, heightening competition. The O'Donnells tried to control distribution around 63rd Street, but Torrio forced them out with threats rather than gunfire. The brothers opened a rogue brewery in Evergreen Park that could produce just twenty-five barrels a day for distribution in that suburb as well as Summit and Aurora. The illegal activities were covered up by justices of the peace and petty politicians.

Stockyards boss Ralph Sheldon had the might of his plump, six-foot lieutenant Joe Saltis. But after the east European immigrant was acquitted of murdering a deputy marshal and no longer needed Sheldon's support,

he started his own gang by bringing liquor down from Wisconsin. To make up for the sparseness of his outfit, Saltis lured Frank McErlane away from his former boss. The *Illinois Crime Survey* would call him "the most brutal gunman who ever pulled a trigger in Chicago," yet he was said to carry a rosary in his pocket.

Hijacking was now a widely accepted word because the crime was so widely practiced. Saltis set up a deputy sheriff and a saloonkeeper who had helped a rival "knock off" one of his liquor deliveries. The men were lured to a meeting and then killed on the Far South Side in late December. Despite the 1923 truce, the year saw fifty-two murders involving criminals in some way, more than double for the year before Prohibition.

3

1924

Something clandestine occurred in late 1923 or early 1924—possibly a secret political arrangement or an agreement with corrupt police officials. Suddenly, bootleg gangs acted as if they owned the city, and in a way, they did. Violence now erupted over minor grievances, and some of it was carried out in crowds. On January 19, 1924, a quarrel broke out somewhere between marginal politician Davey Miller and North Side gangsters Dean O'Banion and Hymie Weiss over a recent hijacking. O'Banion, Weiss and a third man either attended a stage comedy at the downtown LaSalle Theater to follow Miller out or they waited outside and ambushed Miller and his brother Maxie as they were leaving. Both were wounded but survived and declined to help the police.

Chicagoans in general were not merely tolerating open criminality, they were feeding it with their envy and excitement, whether by keeping up with gang exploits in newspapers or patronizing speakeasies to glimpse a rumored hoodlum. One thing making gangs so attractive was the complicity of people in lawful capacities. Prohibition agents, warehouse men and company clerks helped O'Banion steal $1 million in whiskey over five months in 1924 from the Sibley warehouse with "kited" (altered) liquor permits. Then 1,700 of the impounded cases were stolen out from under government noses and put on trains for New York.

Louts were also forcing their way into labor groups as never before, splitting locals of every description into warring factions. On February 4, 1924, a streetcar men's fundraising dance organized by the truck drivers

and chauffeurs union ended in screams and gunfire. Former jockey Anthony Kissane and several others indiscriminately fired down from a balcony with pistols and a shotgun. They killed one man and wounded a dozen more people. Acquitted months later, Kissane turned to election terrorism.[42]

The shooting evidently had been arranged by the national teamsters union as part of the on-and-off "cab wars." The issues are too complex to be related here, although the fighting took several lives over the years. In brief, the conflict was between the Chicago teamsters and the national organization; between the Checker and Yellow cab companies; between Checker drivers and their management; and between Checker and mobsters trying to take control of both the company and its union locals.

Another product of those crazy times was a youth culture. A divide had arisen between generations following the terrible losses in the Great War and influenza pandemic that followed. Young adults visited every place selling liquor, spent their pay on cars for reckless drives and gambled their savings on risky schemes and investments. Anyone trying to live without risk was left behind.

THE CICERO TAKEOVER

With the Dever administration making it difficult for Torrio to sustain a large liquor network in Chicago, he apparently thought of opening a branch in morally bankrupt Cicero. Most liquor trucks from points east took a detour through the largely Bohemian community of fifty-five thousand rather than chance being stopped by Chicago police or federal agents. This was an especially good time for a takeover because Democrats were trying to overturn the corrupt Republican hold on the town.

While other suburbs were dark at night, the Cicero entertainment district was brightly illuminated in a trashy way. At a time when any form of wagering except at racetracks was illegal, the factory community's gambling places included not only several large casinos but also nearly every candy shop and cigar store. These and the brothels, dance halls and 143 hard-liquor saloons just across the street from the western boundary of Chicago drew patrons from across the Midwest.

It seems that Torrio signaled his intention by having Sheriff Hoffman make slot machine raids at resorts run by the three men in a position to stand in his way: meek-looking village manager Joseph Klenha and the bootlegging brothers Myles and William "Klondike" O'Donnell, no relation

to Spike O'Donnell of the South Side. Impressed by this show of power, Cicero Republican committeeman Edward Konvalika talked over Torrio's offer with town gambling chief Edward Vogel. But Torrio wanted to focus on the South Side and asked his enforcer, Al Capone, to take the initiative. Town officials assured him that if all incumbents were reelected, the police would let him run any "resort" he wanted, meaning speakeasy, casino or brothel. Chicago Judge John Lyle reported that part of the deal allowed Klondike and Myles O'Donnell to keep "certain beer territories."[43]

For extra manpower, Capone enlisted help from O'Banion. On election eve, the combined North and South Side gangsters shot up the headquarters of the Democratic challenger for village manager, Rudolph Hurt, and sent him running across the street. On election morning, April 1, 1924, Cicero police allowed dozens of gangland autos to cruise around. Bruisers would climb out to assault Democratic election workers as young as fourteen. A few polling places were invaded and ballots ripped from terrified voters. The Democratic candidate for town clerk was gun-whipped in his real estate office, and five mobsters pummeled a precinct worker in a rear room. Another was slugged and kicked inside a garage with blood on the floor and bullet holes in the walls.

Ten dozen Chicago policemen were hastily deputized to assist eighty Cicero policemen and deputy Cook County sheriffs. The first Chicago squad stopped Capone's older brother Frank, the best-looking in the family. Possibly unaware the plainclothes men were officers, he broke free at 21st Street and Cicero Avenue. The official account said he fired twice at them, but then his pistol jammed before he was killed by two detective sergeants.

All incumbents were reelected and Al settled in, gaining more in power and experience than he would have at Torrio's side. From then on, Cicero saloons outside the Klondike and Myles O'Donnell territory were supplied with real beer exclusively from Torrio's breweries. Capone initially worked out of the Hawthorne Smoke Shop casino but later moved across the way to the Hawthorne Inn, yet reporters and the police still considered him as unimportant "Toni Caponi," alias Al Brown.

Capone's largest single source of income may have been from the Ship casino near the Western Electric plant. Arrivals were scrutinized through a peephole although there was little chance of a raid. Village manager Klenha had taken instructions from local gangsters for years and may not have welcomed domination by a little-known Chicagoan. This led to a legend that seems either fictional or greatly exaggerated. Klenha supposedly told reporters he had accepted mob assistance in the election but would serve

independently. "And in this I refer particularly to those gangsters," Capone and Torrio. "They can get out and stay out." In response, goes the story, Capone called Klenha out and slapped him unconscious or knocked him down the steps. Capone supposedly then kicked him, with two policemen afraid to do anything to the new boss of Cicero. The story seems unlikely on the face of it, and the city hall had only two steps.

Corruption is sometimes more than taking an envelope under the table. One way or another, smarter Chicago gangsters found ways of obtaining a hold on respectable people who might prove useful. Raids showed that some businessmen and jurists such as municipal court judge Joseph Schulman would leave IOUs for thousands of dollars at hoodlum-fronted casinos.[44] One wonders if these influential personages intended to pay up or if, by leaving their markers, they were willing to do favors when called on.

No one tried to attack Torrio's organization while his second-in-command was away, suggesting a stabilizing element. The Chicago Crime Commission, the Illinois Association for Criminal Justice and a high-level police source—possibly Captain John Stege, who will be described later—reported without providing details that unnamed politicians had drawn the latest territorial boundaries.[45] In doing so, they may have been more interested in maintaining a flow of bribes than in keeping the peace.

The Reverend Elmer Williams, law enforcement director for the Better Government Association, charged that after Dever's election, a Democratic leader he would not name—perhaps Cook County party chief George Brennan—told aldermen to leave liquor graft up to ward committeemen, many of whom were friendly with gangs. The minister also charged that liquor removed from a government warehouse was being sold to stockbrokers and other affluent customers. Williams's accusations must have been accurate, since his front porch was bombed in April and his source was shot to death while driving in suburban West Chicago.[46] Major outfits had grown so large by mid-1924 that they possessed characters all their own:

THE TORRIO-CAPONE GANG. Police Superintendent Collins called Torrio "perhaps the most powerful underworld figure in the city" because of his hold on downtown, Cicero, the 22nd Street entertainment district and, through alliances, most of the South Side through deliveries of beers and liquors. Afraid he might be imprisoned for a second Volstead arrest, John was grooming Capone to take over everything.

THE GENNA GANG. The dual concerns of the Near West Side brothers were producing raw alcohol for flavoring by bootleg gangs and maintaining

political control of Little Italy. The Gennas at times imported Sicilian killers. Seized records would show that the six brothers paid off 150 policemen at the Maxwell Street station alone and around 150 outside the district. John Powers was still alderman, but now in his seventies he was in poor health and no longer a strong influence.

THE DRUGGAN-LAKE GANG. These two affable friends had risen from common thieves to millionaires in four years because of their discipline in managing licensed and rogue breweries. Terry Druggan and Frank Lake were not interested in hijacking, smuggling or manufacturing hard liquor, and there is no record of their bothering other gangs. Their outfit had no specific boundaries, contrary to a bogus gangland map, and since there was no mention of regular members its ranks may have been street toughs hired for specific jobs, such as guarding beer shipments. As with Torrio, their known financial backing came from the Stensons.

THE NORTH SIDE GANG. Dean O'Banion would jump at opportunities but showed little imagination. His impulsiveness was balanced by the calculating nature of right-hand man Earl "Hymie" Weiss. Their strongman was Vincent "Schemer" Drucci, and later members would include George "Bugs" Moran. The gang concentrated on the North Side away from the Gold Coast, granted franchises to independents and hired out for election terrorism, as it did in Cicero. O'Banion had no quarrel with the South Siders but would battle the Genna gang for trying to push him away from their common boundary.

THE "SPIKE" O'DONNELL GANG. From a headquarters in suburban Evergreen Park, former bank robber Edward "Spike" O'Donnell and his younger brothers ran a modest distribution business in part of the stockyards area and some of the lesser southern suburbs. Unlike Torrio and Capone, the O'Donnells thought small and used fists rather than strategy. Spike's refusal to compromise was about to make him the most shot-at gang leader in Chicago history.

THE SHELDON GANG. With Torrio's support, Ralph Sheldon forced stockyards-area saloonkeepers to buy beer from breweries run by larger gangs. His outfit was less feared after losing its two most dangerous members, Saltis and McErlane. Ralph recruited a few Italians and several Irish hoodlums from the Ragen's Colts street gang. All four of his known remaining members—Ralph's brother, Stanley; John "Mitters" Foley; Jacomino Tucillo; and Frank Delaurentis—would meet violent deaths.

THE SALTIS GANG. Joe Saltis rancorously broke away from Ralph Sheldon and was now using disturbed Frank McErlane to terrorize people in the

immigrant and working-class Back of the (Stock) Yards community, with steady payoffs going to police in the New City district. One never knew when indecisive and impulsive Saltis would infringe on someone's territory, pull away, move out or return. From news accounts, it seems that he encouraged McErlane's violently irrational behavior merely for the excitement.

THE "KLONDIKE" O'DONNELL GANG. Tubercular Myles O'Donnell began a Far West Side outfit and moved it across the street to Cicero. Because of Myles's failing health, his brother William "Klondike" took over but was less of a leader. A third brother, Bernard, supervised the family's lone rogue brewery. With permission from Capone, these O'Donnells continued meeting some of the beer demand in Cicero and would later force their way into Chicago's greater West Side. Klondike sometimes provided Saltis with additional manpower, but the two gangs were not allied.

THE INDEPENDENTS. These included robber and former jockey Tony Kissane of the Teamsters dance shooting and "Dapper Dan" McCarthy, suspected in at least two murders by mid-1924. Two other independents, Claude Maddox, a Capone ally, and the possibly psychotic William "Three Fingered Jack" White were primarily robbers but engaged in liquor trafficking when the chance arose. Then there was Billy Skidmore, a bail bondsman who grew wealthy arranging acquittals and doing other favors. He was said to know every thief in town. News accounts mentioned without giving details that high-level politicians were acting as independents by financing bootleggers or backing speakeasies. Ground-level politicos supporting gang activity included Morris Eller of the Sanitary District and his son, Judge Emmanuel Eller.

Such was the general order, and even the surprises fit a pattern. On May 8, 1924, Capone came from Cicero and entered Hymie Jacobs's saloon at 23rd and Wabash, half a block from Torrio's Four Deuces headquarters. There Al personally killed minor hijacker Joe Howard. It was said that a short time earlier the good-looking Howard had a spat or scuffle with Torrio man Jake Guzik. As a consequence, Capone stepped up to the bar and supposedly demanded that Howard apologize. In the usual version, Howard taunted him as being nothing more than a pimp. The insult allegedly so enraged Capone that he shot Howard at close range.

Perhaps, but this standard account seems only a guess. There is no other mention of Capone's behaving with murderous rage, though sometimes he threw things when angry. Besides, why would he endanger Torrio's confidence in him and total control of Cicero just because someone's underling had

insulted him with what others must have said for years? In addition, Jacobs said that from what he could tell from another room there had been no quarrel, and that Howard said, "Hello, Al," in a friendly tone just before being shot—as a newspaper put it—"without a word of warning."[47]

So maybe there is another explanation. As a long-range planner, Capone intended to take over the Unione Siciliana despite objections that he was not Sicilian. Luigi Barzini, an Italian explaining his people to Americans, noted that Sicilians admired power and prestige over wealth. Capone might have cold-bloodedly killed Howard on a slender pretext just to win respect from the Sicilian sector. It might be noted that he chose a non-Italian as his victim. But the murder was wasted—Sicilians would never accept him. And the police could not care less who killed Howard.

In contrast to Capone's deliberate nature, Saltis gunman Frank McErlane's instability was a rising concern. While drunk at an Indiana saloon in May, he killed a patron, attorney Thad Fancher, possibly in one of his delusions. Friends hurried McErlane to Chicago, and Governor Small put off signing extradition papers for months. During that time, McErlane was suspected of fatally beating a murder witness during another rage.

Federal agents in fisherman's hip boots later waded through suds flooding the basement of the Malt Maid brewery on 39th Street, which Torrio had bought through the Stensons. After they brought up a pail of real beer for evidence, the place was padlocked but was reopened under another name and ran rogue. Learning nothing from the incursion, Torrio subleased the former Sieben brewery. Dean O'Banion held shares and proposed selling Torrio his share for $500,000 and even offered to help him remove a shipment.

Men under Torrio, O'Banion and North Sider Louis Alterie began a huge predawn withdrawal on May 19, 1924. Alterie was the most distinctive of all Chicago gangsters: six feet tall, he sometimes dressed as a cowboy from his years on a California ranch. He was essentially a poseur, more often talking revenge than taking it. At present, he was the "business agent" for a union and fronted for a speakeasy.

So there they were, Torrio, O'Banion and Alterie, watching over more than thirty "yeggs" loading trucks with barrels of 4 percent beer. Tipped off, fifteen policemen came out of concealment for a roundup. Fifteen other officers ran after anyone trying to escape. Superintendent Collins showed up and personally pulled the stars off the uniforms of the three patrolmen who had been in charge of watching the plant overnight.[48] Prosecutors claimed that Spike O'Donnell was also somehow mixed up in this, and so he would be indicted with the others.

A popular belief, based on the unsupported North Side/South Side myth, was that Dean O'Banion had engineered the raid to send Torrio to prison and let himself be arrested with the others. But O'Banion was not particularly clever. So the police might have been tipped off by Druggan and Lake, since they had more brewery contacts and a sense of humor. In addition, Torrio showed no animosity toward O'Banion over the raid, but Druggan and Lake were not seen around for a while. When they showed up, they were put in jail for a year for producing real beer at their Standard brewery.

The Torrio and O'Banion arrests were eclipsed by the "thrill murder" of fourteen-year-old Bobby Franks by Nathan Leopold and Richard Loeb, the brilliant sons of two wealthy South Side families. The boy was struck with a chisel in a car on May 21 and his body shoved into a culvert. Both young men were sentenced to life in prison, where Loeb would be killed by another inmate.

With the local Democratic Party fractured by ineffectual Mayor Dever, canny county board president Anton Cermak found ways of undermining him over the next three years and presented himself as a viable successor to a man whose concept of leadership was making speeches.[49]

Though shootings had increased, the general tempo of the city was slowing. Flappers were less invigorating, and going to a speakeasy no longer carried the spark of naughtiness. But "speaks" were the only locations besides office water coolers where the sexes could mingle on an equal basis. The conservative *Chicago Tribune* ran a tongue-in-cheek series on "Speakeasy Girls," meaning "Debutantes, Business Girls, Old Fashioned Girls, Morose Girls, and Wealthy Playgirls" who might be seen speaking to a gigolo.[50] A newspaper also featured speakeasy ensembles for being well dressed but not overdressed.

At least in speaks and legal cabarets, the gangster influence was hidden. But mobster control could be seen everywhere else, including the fear shown by a particular murder witness. "Put yourself in his place," the *Tribune* said. "When he went to a coroner's inquiry, the gang ruled it. He was placed between two members. The gangster told a newspaper photographer that he would be thrown out the window if he tried to take a picture. The jury was composed of men obviously intimidated. They did [not] hold the six men to the grand jury. That is not important except as it revealed successful terrorism."[51]

Chicago was now in its most reckless period. Gunmen burst into hotel lobbies to hold up the office, a businessman and his wife were forced into a car and robbed while leaving a Loop theater and thieves blew open four safes in the same building simultaneously. Raiders at a place on North Clark Street's "cabaret row" nailed the doors and windows of one place shut

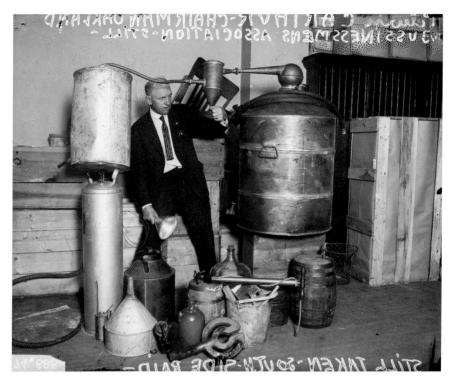

Above: Government agent Edward Arthur stands by still equipment from a raid. *DN-0074685*, Chicago Daily News *collection, Chicago History Museum.*

Opposite: George "Bugs" Moran (*second from left, no tie*) in felony court. *DN-0093634*, Chicago Sun-Times/Chicago Daily News *collection, Chicago History Museum.*

because the front man refused to name the leaseholder, evidently someone in the rackets or public office.

Women were more involved in criminal conduct than at any other time in city history, with a moll or two usually following robbery bands, women shooting men in public and, in August, one scarring the face of a pretty rival with carbolic acid inside city hall. A week later, a teenage girl was arrested for strangling a woman with a telephone cord so that she and her friends could plunder the house. "Bugs" Moran and rising North Side gangster Ted Newberry critically wounded rich bootlegger Harry Morley on behalf of his gold-digging wife because he was seeing what newspapers called a "bobbed hair blonde." Philandering Morley would make news again the next year when another young woman died of accidental alcohol poisoning in his downtown hotel room.

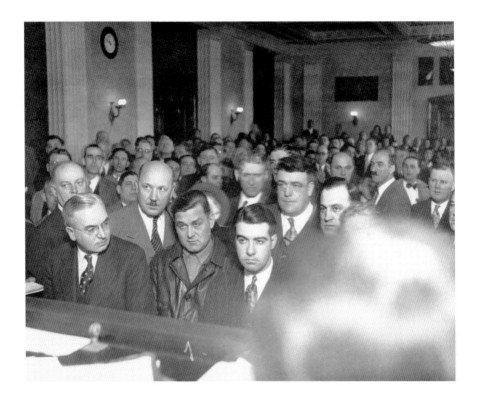

Moran had joined O'Banion's outfit after buying a parole from Governor Small in 1923 to cut a robbery sentence short. The unremarkable criminal had grown up under the whippings of his father; found companionship in the rough street gangs of St. Paul, Minnesota; and then escaped from a juvenile home. In time, he felt the lax law enforcement in Chicago suited him.

Just when authorities thought they had seen all the ways to profit from Prohibition, they discovered that fake synagogues across Chicago diverted most of the sacramental wine arriving for the September high holidays. An investigation showed that three-fourths of the city's 272 Jewish congregations existed only on paper, and one address was that of a Protestant church. Bootleggers who set up the scam used forged permits to redirect the wine to the black market. This caused such a scarcity that legitimate wine dealers gave the ring $100,000 to meet their orders. The payoff headquarters was the downtown office of Prohibition official John Psichalinos, and suspected of being behind the schemes were former Prohibition enforcement director Percy Owens and state senator Lowell Mason of Oak Park. With their influence, both were acquitted.[52]

In early November, bantam gangster Anthony Kissane was riding to a polling place with robber Claude Maddox and John Mackey of the former North Side gang of thieves. They intended to rough up voters on behalf of a truck drivers union official running for Illinois senate. Their auto was intercepted by a car with four men believed hired by the international teamsters union. Mackey was killed, and Kissane was wounded in window-to-window gunfire. Without gangster support, the candidate list.

As everyone knew, the only North Side/South Side friction was personal. Dean O'Banion was not normally a businessman, but word got around that he wanted to run beer to Cicero despite Capone's agreement with Myles and Klondike O'Donnell. Al appeased Dean with a 15 percent share of the Ship's profits, but the North Sider hated being lorded over by Italians. The tension increased when Capone strongly advised O'Banion to remove a cheating friend named Bates as manager of the Hawthorne Smoke Shop casino in Cicero. On November 3, 1924, Capone held a meeting at the Ship to discuss the situation.

All of the partners agreed on changing Cicero liquor distribution to keep O'Banion happy, but then Capone suggested forgiving Angelo Genna's $3,000 marker for gambling losses at the Ship.[53] Capone may have hoped the Gennas would be so thankful they would let him take over the Unione Siciliana now that its conciliatory president, Mike Merlo, lay dying of cancer.

With millions rolling in from prostitution, liquor and gambling in the wide-open suburb, $3,000 hardly seems noteworthy. But this was the second time Capone had inserted himself into matters concerning O'Banion, and Dean's temper exploded. After leaving the room, O'Banion grabbed a phone and ordered Angelo to pay up or else. When Torrio learned that Dean was impetuously risking a gang war by acting on his own, he might have let the Gennas know he would not mind if they eliminated the Irishman despite the precedent it would set. There also could have been an underlying element in the enmity. O'Banion kept insisting that Torrio and Merlo, as leaders in the Italian community, restrict the Gennas to the established boundary for the West Side. Instead, the immigrant brothers waited until the right hit men could be arranged.

A break-in during the uneasy pause shows where some gang leaders might have kept their stash. Veteran thieves tied up an Empire Storage Company guard, used a diamond drill bit to cut through the thick glass of an office door and then attacked a brick wall. Once they broke through, more than four hours later, they looted as many as thirty targeted metal boxes. A company official told the police that all had been empty, an apparent lie

indicating that whatever taken must have come from illegal activity or was being hidden from divorce lawyers and tax investigators.

When Merlo died the next day, November 8, Unione Siciliana members and bootleggers paid $100,000 just for floral arrangements and $5,000 for a wax likeness to be placed in an open car for the cortege. New York gangster Frankie Yale, who may have killed Big Jim Colosimo in 1920, arrived in advance and, speaking as head of the corrupted New York branch of the Unione, let it be known that Angelo Genna would be a better leader of the Chicago branch of the Unione.

Two days after Merlo's death but before his funeral, three men entered O'Banion's flower shop across from Holy Name Cathedral, at State Street and Chicago Avenue, as if placing an order. The customers may have been Yale and the Gennas' new Sicilian assassination team of John Scalise and Albert Anselmi. O'Banion greeted them with a handshake, and they made small talk. When the porter left to mop another room, the visitors blasted away. O'Banion died bleeding from the chest, throat and back of the head. The larger wounds were made by Italian-style "dum dum" bullets, slugs that have been drilled and reshaped to expand on impact.

The killing might have sparked a gang war, but two days later, Maxie Eisen of the North Side gang and Tony Lombardo, a Capone confidant from Sicily, began peace talks with various outfits, and there were no reprisals, although hatred simmered as ten thousand people, many from across the country, attended Merlo's funeral.[54]

On November 14, thousands lined up to watch O'Banion's twenty-four-auto procession. North Side gangsters wept in the chapel at the $100,000 funeral, and Judge John Lyle would call it "the most nauseating thing I've ever seen in Chicago." Honorary pallbearers were Mayor Dever, State's Attorney Crowe, County Board President Cermak and Police Superintendent Collins. A short time later, Capone went to New York and came back with several bodyguards with no ties to anyone in the Windy City. Rival gangs left him alone, but he still had to watch for independents such as Chicago police lieutenant Albert Winge. In addition to being known for beating prisoners, Winge was a major stockholder in a brewery illegally producing strong beer. He also headed a bootleg band financed by several unnamed city hall figures. Winge's criminal life was discovered when Cicero police, possibly acting on Capone's behalf, caught him guarding beer trucks in the suburb.

Taking over the North Side mob after the O'Banion assassination, Hymie Weiss made the outfit harder and bolder. Although raised a Polish Catholic, Henry Earl Weiss had a Jewish-sounding last name because his family had

altered it from Wojciechowsky. After his parents separated, he took on the rough ways of his absent father, setting him against the rest of the family. Henry suffered from undiagnosed headaches and fainting spells all his life and walked with a cane. He would sometimes rest on a couch on the second floor of the Schofield flower shop, its name unchanged since Nails Morton bought the nondescript place as a front.

The Dever administration had honesty at least in the top levels of the police department. Overworked in a job that was more important than superintendent, Chief of Detectives Michael Hughes stepped down in November. Taking over a demoralized force, the unassailable Captain William Schoemacher forged a team with the new commander of all fifty-one crime squads, Captain John Stege. This small and ordinary-looking official knew what life on the streets was like; as a teenager he had killed a man beating his mother. Together or singly, Schoemacher and Stege would lead the department for much of the remaining Prohibition period, despite

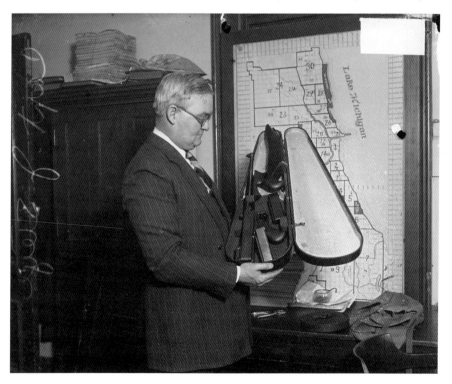

Captain John Stege showing how a tommy gun might be concealed. *DN-0081396,* Chicago Sun-Times/Chicago Daily News *collection, Chicago History Museum.*

temporary demotions. But there was too much money flowing through the gutters of local government for them to make a noticeable difference.

Throughout that autumn, the Ku Klux Klan from outside the city campaigned for Governor Small's reelection. This, and Capone's backing, helped the embezzler win at the polls on November 25 despite disclosures of his selling pardons. Voters wanted nothing to stop the flow of their liquor.

Though Christmas was approaching, assorted crimes dimmed any joy. On December 6, thieves cut through five steel doors at a government warehouse and used fire axes on a wall to reach the whiskey stored. After hard questioning by Shoemaker and Stege, one of the watchmen poisoned himself rather than shame his family with a trial. Shoplifting and wallet pinching in crowds had increased so much that the State Street Merchants Association urged Judge Lyle to set higher bonds. Sums for pickpockets are unknown, but the judge now set bail at up to $100,000 for robbers and gunmen. Billy Skidmore, godfather of Chicago thieves, yanked on his political connections and had him transferred to a court inside a former movie house in the black belt.[55] The Chicago Crime Commission's gangland murder count for 1924 was fifty-four, including lives lost in union takeovers and quarrels between hoodlums. The worst was yet to come.

II

THE LONG NIGHTMARE

The only people we have to fear is each other.
There's plenty of business for all of us.

—Al Capone, interview, 1927

4

1925–1926

Twelve days into the new year, either the North Side gang or the Gennas curbed Capone's auto at 55th and State for a barrage of gunfire. The bullets grazed the chauffeur and came close to hitting Al's gangster cousin, Charles Fischetti, but Capone was elsewhere. Since no one was seriously hurt, those thirty shots may have been only a threat. That same day, the city council Finance Committee rejected a measure to hire one thousand more patrol officers and raise the starting salary by $100 a year to attract reputable recruits. The aldermen liked things the way they were.

Ever concerned about protecting himself, Capone ordered a custom-built $200,000 Cadillac, believed the world's first private armor-plated auto. Its combination locks meant enemies would never force him out. Despite the added metal, the V-8 engine was capable of propelling the auto up to seventy miles an hour, and the rear window lowered to permit firing from the back seat. Like new detective bureau cars, this was a classic dark green with swept back black fenders. Wherever the war wagon went, there was a scout car darting in and out of traffic no more than a block ahead and a six-seat touring car of gunmen traveling behind.[56] Capone was so fearful of becoming a target that he used this rolling fortress even for short distances.

On January 17, 1925, Torrio was sentenced to nine months in DuPage County Jail as a result of the Sieben brewery raid in Chicago. The penalty was light because two government witness had been killed, one by the police. Torrio had to serve his time in a suburban facility since the city lacked a federal jail, and the Cook County Jail at Illinois and Dearborn Streets was at double capacity because of Prohibition arrests.

With a few days before reporting to jail, Torrio had his chauffeur take him downtown for business and so his wife could shop. When his chauffeur returned to the couple's commonplace brick apartment building, a blue Cadillac pulled up with reportedly Schemer Drucci at the wheel. Hymie Weiss jumped to the pavement with a shotgun, and Bugs Moran fired a forty-five-caliber automatic in revenge for John's role in O'Banion's murder. Packages spilled from Torrio's hands, and he fell with blood gushing from his jaw. Moran put the pistol muzzle to his head, but the gun gave an empty click as a laundry truck rounded the corner. The gunmen left their badly wounded victim behind.

At the hospital, this most powerful of all Chicago criminals pathetically screamed about possibly garlic-coated slugs, believing they caused a poisonous infection. "Cauterize me!" Torrio kept saying though his shattered mouth, "cauterize me!" The next month, he was taken by ambulance to the federal building to begin his term although weakened and his lower face still bandaged.[57] Capone personally gave him an escort.

The twenty-six-year-old mob leader grew quickly into his expanded role as chief of the South Side as well as Cicero. He was generally well-liked though mercurial. With some practice, he became so pleasant with reporters that they regarded him as a "real guy" and respectfully referred to him as "Mr. Capone." But with his lieutenants he was stern and always alert for signs of betrayal.

Gang influence on Chicago politics was becoming more visible. Sheriff Peter Hoffman had allowed wealthy multiple brewery owner Terry Druggan special privileges, such as cell visits from a pretty secretary and don't-forget-to-come-back furloughs. Hoffman, satirized in *The Front Page*, covered up his bribes by claiming the not very violent gangster had threatened his burly guards unless he received special treatment.[58] Then Ralph Sheldon caused a stir by trying to usurp Saltis's hold on stockyard politics. During the February election, his brother, Stanley, was killed by a patrolman while trying to abduct a Republican election clerk. After that, Ralph became less aggressive.

In March, at least ten patrolmen and a lieutenant were caught selling confiscated liquor *inside* the North Side Sheffield police station near Cubs Park (Wrigley Field). Customers were seen walking out with bottles in wicker baskets. But there was no shakeup, because money made friends. The nature of bribery was such that Cook County judge James Comerford complained that about the only people brought before him were "forlorn Negroes" and called for officers to bring in more white offenders.[59]

The dormant Thompson machine was stirring back to life now that "Big Bill" had announced he would challenge Mayor Dever in 1927. Capone may have seemed all-powerful by then, but his downfall had already begun. Police under Schoemacher learned that Al's lieutenant Frank Nitti kept the gang's financial records in a dummy medical office at 21st and Michigan. On April 6, 1925, the officers burst in, arrested Nitti and found a staff of twenty-five keeping ledgers, card indexes, memorandum accounts and daybooks on Capone's rackets. One detail the documents showed was that Al was setting aside possibly 25 percent of everything for jailed Torrio. The gang did not seem worried about the raid, but the material provided the start for several extensive investigations leading to Capone's crippling tax charges in the thirties.

Daily newspapers were still light on the gangster king, but the *Cicero Tribune*, run by young Robert St. John, and the neighboring *Berwyn Times*, managed by his brother, Archer, carried weekly stories of gang beatings and Capone-rigged contracts. Furious Berwyn citizens burned down an empty Capone bagnio on a Sunday morning. In retaliation, Ralph Capone and others jumped twenty-two-year-old Robert St. John on April 6, the day of the Capone records raid, and severely beat him as two policemen stood by. Other men forced Archer into a car and held him handcuffed in a shack as a threat. Capone paid Robert's hospital bill, acquired the *Cicero Tribune* and put one of his men in charge to make a radical change in editorial policy.[60]

But no one then or now knew the extent of mob beatings and nonfatal shootings. Saloonkeepers brutalized were not considered news, and hoodlums usually drove away with their breathing cohorts before they could be interrogated. Since the police routinely checked hospitals on reports of gunfire, a few doctors maintained secret practices. The Gennas had some physicians on call twenty-four hours a day to stitch up their wounded or sign falsified death certificates. When in town, future bank robber John Dillinger would go to Dr. William Loeser, a German dabbling in after-hours surgery in addition to selling hooch and drugs. Skin specialist Charles Eye of the quiet Northwest Side claimed he could remove fingerprint loops and whirls. And most of the Capone gang got to see Dr. David Omens on Roosevelt Road (formerly 12th Street) at one time or another.[61]

The wild youth in the city was becoming wilder. Two teenage girls and four young men went on a petty robbery spree for the thrill of it. The brains of the outfit was a seventeen-year-old girl who had run away from a juvenile detention center. Later that summer, police closed in on twenty-year-old Edward Carroll and his eighteen-year-old wife following a rash of robberies

of wealthy South Side women. Hearing the police coming up the stairs, the pair jumped to their deaths from a third-floor window off 46th Street. A red-haired girl and her gun-toting boyfriend held up a Capone-connected speakeasy on the West Side. The young man wounded a bouncer, said "Have another for good luck" and shot him a second time.

"Good work, buddy," the girl told him.[62]

Further showing the senselessness of the times, a drunken whim led New Jersey gangster Harry Hassmuller and Spike O'Donnell's debonair brother Walter to hold up a roadhouse in suburban Evergreen Park in June while more than a dozen couples were dancing, dining and drinking. An employee slipped away and opened fire from the front door, killing both. This weakened the jailed Spike's gang at a time when the huge raw alcohol enterprise of the Genna brothers was about to fall apart.

Following a high-velocity chase by unknown mobsters, Angelo Genna was killed with a shotgun in May 1925. At the hospital, he managed to kiss his wife goodbye. Police were sure the murder was Hymie Weiss's way of evening the score for Dean O'Banion's death. The next month, North Siders Bugs Moran and Schemer Drucci were wounded in a shootout with Mike Genna and the gang's professional murder team of Anselmi and Scalise. An hour later, officers chased Mike's speeding black car. The auto smashed into a telephone pole at 59th and Western, leading to a shootout that killed Mike and two of the three officers. Anselmi and Scalise were caught by speaking in Italian as they ran.

Superintendent Morgan Collins announced the next month, "We're out to break the Genna gang." A newspaper reported that Collins and Mayor Dever discussed "arming police squads to go out deliberately and shoot gangsters down."[63] The following day, a gunman resembling Antonio "il Cavalero" Spano walked into chief prosecutor Crowe's outer office and fired a shot that just missed Crowe's small bodyguard, who resembled him. The possibly drunken gunman escaped through downtown's little-known system of intersecting underground tunnels.[64]

Despite a police crackdown on the Gennas, brother Antonio wanted to try a little Black Hand extortion, but one of his victims refused to give in. On July 8, his friend—Spano—lured him away and killed him with five rounds. Sickened by all the funerals that July, Father Gianbastiani tacked this message in Italian to a church door near Death Corner: "Brothers! For the honor you owe to God, for the respect of your American country and humanity—pray that this ferocious slaughter, which disgraces the Italian name before the world, may come to an end." No one cared. As the *Illinois Crime Survey* would

note, "The fact that more Italians than all other nationalities combined were killed in gang murders will occasion little surprise."[65]

Mayor Dever's clampdowns had closed so many stills that elegant Sam "Samoots" Ammatuna looked for other ways to cover his gambling debts, such as skipping a payment into the Anselmi and Scalise defense fund. In July, the flashy gangster and two hired guns walked into the Unione's Chicago headquarters and announced a new leadership. No one dared protest.

A holdup at the Drake Hotel in the Gold Coast cost three lives that month. As five masked robbers scooped $10,000 from a table, one of them was fatally shot by a house detective. A subsequent gun battle killed a second robber and a clerk. The three fleeing bandits roared off but smashed their Lincoln into a tree and were arrested in a second shootout.

Not all gangsters tooled around in fancy autos. Irving Schlig, who blamed his meanness on police beatings, would use a biplane to fly in liquor cases for his henchmen to sell around the stockyards behind Saltis's back. But Schlig had a tendency to gamble away his partners' shares, and so he and a companion were shot execution style and dumped at a Southwest Side air strip. Jules Portugese of the former Schlig gang then crossed a Genna splinter group. As he and his party left a restaurant, two gunmen jumped out of a car and fired as a pair of detectives happened by. One of the officers stood on a running board of the detective bureau auto and kept shooting until being outdistanced. Unhurt, Portugese kept the names of his attackers to himself, and the next day both were severely wounded by shots from a sedan.

The danger of the times could even be seen in justice venues. In August 1925, a spectator in the trial of a North Side robber threw three bullets into the air so they fell on a state's witness to intimidate him. After mobster James Vinci was killed and his brother Mike was fatally wounded, third brother Salvatore "Sam" forced his way into the inquest room and lunged at a lying witness, but the police ejected him. Sam returned with a gun minutes later and killed the man, leading to a twenty-six-year sentence.[66] In 1928, a veteran Prohibition agent would be seriously wounded as he was about to take the stand in a federal courtroom.

A political fixer for the weakened Genna gang, Aniello Taddeo, had recently bought the Venetian Cafe in Oak Park but seems to have backstabbed someone. As a Hudson touring car swerved within two feet of him on a street in September 1925, he was felled with a shotgun and automatic pistol. Although reporters gave police in the usually peaceful western suburb a list of possible killers, no action was taken. That same month, the Federal Council of Churches charged in Washington that respect for laws had been

crumbling ever since the Eighteenth Amendment took effect. As James Cagney wisecracks in a 1931 film, "The age of chivalry is dead. This is the age of chiselry."

With Spike O'Donnell newly released from jail following the Sieben raid, Joe Saltis and Frank McErlane wanted superior firepower to drive the Irish brothers away from the stockyards. Unstable McErlane bought a Thompson submachinegun at a sporting goods store for $175, although they were intended only for the military. As the often-smiling Spike walked by a drugstore near 63rd Street on September 25, 1925, McErlane called out his name and brushed the tommy gun back and forth, shattering windows as he used up an ammunition drum of one hundred rounds. This was the first use anywhere of a tommy gun in urban warfare. O'Donnell was shaken by the threat although only slightly wounded.[67]

In October, the public was alarmed by the first murder of an agent of the U.S. Bureau of Investigation, not yet called the FBI. Agent Edward Shanahan died shooting it out with stolen auto ringleader Martin James Durkin at a 62nd Street repair garage, leading authorities on a long manhunt until he was

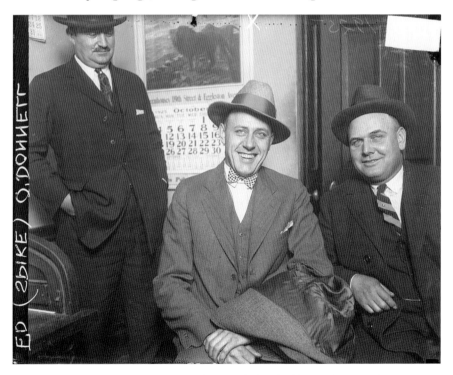

Gang leader Spike O'Donnell, the most shot-at criminal in Chicago history. *DN-0079383*, Chicago Sun-Times/Chicago Daily News *collection, Chicago History Museum.*

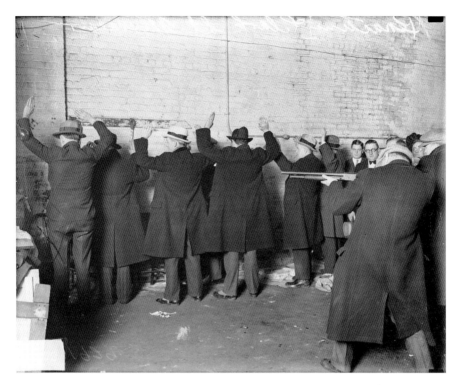

Reenactment of the St. Valentine's Day Massacre. *DN-0087708*, Chicago Sun-Times/ Chicago Daily News *collection, Chicago History Museum.*

found. Three days after Shanahan was killed, Saltis and McErlane ambushed members of the Spike O'Donnell gang in Evergreen Park. No one was seriously hurt, and Spike was taken to the house of correction infirmary so he could be questioned, protected and patched up at the same time.

A jury convicted Anselmi and Scalise of manslaughter in one of two police killings in the gunfight in which Mike Genna died. Because of payoff disclosures made during the trial, every officer in the Little Italy district was transferred except for honest captain Ira McDowell. A neighbor picking up a package left outside McDowell's home was killed when it exploded.

Now fully in charge of the former Torrio gang, Al Capone sometime in 1925 let his brother Ralph look after his interests in Cicero and took over part of the Metropole Hotel, at 23rd and Michigan, near the old Four Deuces. Eventually, he would command fifty rooms, two with exercise equipment.

Capone was delighted that November when his Sicilian liaison, Tony Lombardo, was elected head of the Unione Siciliana over showy incumbent Salvatore "Samoots" Ammatuna. Rumor had it that the

loser was planning a raw-alcohol business in defiance of the remaining Genna and the Klondike O'Donnell gang members of Cicero, who were entertaining the same idea. So a pair of gunmen dashed into a West Side barbershop as Ammatuna crawled behind the fixtures and killed him with a slug to the neck. Apparently, the same men then engaged in five more killings to eliminate his small organization.

Robbery leader William "Three Fingered Jack" White wore gloves so no one would notice that one hand was missing two fingers from an accident. The fleshy man had been locked away in an institution for the criminally insane until he bought a special pardon from Governor Small. But most people were unaware of him until he escaped a roadhouse police trap by killing a Forest Park policeman. White would not be caught for several weeks.

Small's "pardon mill" had now gone too far. Illinois attorney general Oscar Carlstrom declared that the governor had unlawfully changed the conviction of millionaire's son Ira Perry Jr. from murder to manslaughter for a fatal shooting during a jewelry holdup. This allowed Perry to be paroled after serving only three years of a life sentence. As soon as Small signed the paper, state employees escorted Perry 130 miles from Joliet Prison to the Iowa state line before a judge could void his release.

The year 1925 racked up sixty-six gangland murders. Early the next year, quixotic Judge John Lyle complained from the bench that a gunman no longer wanted lawyers to defend him, "he wants fixers." In a 1932 film, a mobster who has just shot someone in the head casually tells his attorney while getting into evening clothes, "You're my lawyer, *you* do my worrying for me." When Lyle set bail totaling $3 million for a pair of typical robbers, he was swiftly transferred down to attachment hearings. Even then, he struck a nerve by blaming fellow judges for the plague of crime.

An indictment unsealed in January 1926 charged that wealthy horse breeder John Harris, working out of a Lake Shore Drive office, headed a Gold Coast drug ring dealing with an immense amount of opium smuggled from New Orleans. So much money was involved that the case never came to trial. Police expressed shock to learn in the same month that killers were freelancing. A "murder trust" member claimed that the wage for taking a man's life was one hundred dollars and a train ticket out of town. Among the persons involved in killing-for-hire was Genna brother-in-law Harry Spignola, and police guarded his home because he was a potential witness. But when Spignola left a pinochle game near his home on January 10, his friend Orazio Tropea held a match to the window. An imported shotgun man came out of a car and blasted Spignola in the street.

If Capone knew anything about the painstaking Internal Revenue Bureau investigation into his spending, he made no changes in his routine. Jumping ahead, Capone came to distrust Italian gangsters who might be secretly aligned with another gang, so for special assignments he called on his "American [non-Italian] boys": murderous Fred Burke and his friend Gus Winkeler, Bob Carey, Raymond Nugent and Fred Goetz. All were possibly vouched for by robber Claude Maddox, who knew them in his St. Louis days.

What had been Capone's South Side outfit evolved into a super-gang when gambler "Dago Lawrence" Mangano delivered part of the West Side to him in February, in return for protection after a bomb from a rival tore through his nightclub as patrons dined. A few months later, Martin Guilfoyle merged his West/Northwest Side beer operation with Capone's. Presumably after clashes that never reached print, "Scarface Al" allowed African Americans to keep spinning their policy wheels as long as they refrained from beer deliveries. Al was now in control of Chicago one way or another from North Avenue down to several southern suburbs.

A 1926 minor "beer war" began when saloonkeepers around the stockyards were forced to come up with ten dollars more per barrel of needled (alcohol-injected) beer from Ralph Sheldon's outfit, which held a Capone franchise. Nemesis Joe Saltis was pushing sales at the old price of forty-five dollars. During the back-and-forth fighting, Sheldon's car was shot up, his home was bombed, two bystanders were wounded by McErlane's rat-a-tat and at least two saloonkeepers died.

Orazio Tropea, who had played Judas in the Spignola murder, was put in charge of collecting forced contributions for the new Albert Anselmi–John Scalise defense fund, as the men faced prosecution for killing a second officer in the Mike Genna shootout. For pocketing thousands of dollars, feared Tropea was blown away in February. His chauffeur was beaten and finished off with a shotgun. Anselmi and Scalise were later acquitted at the terrible cost of $100,000 in bribes and what police said were the murders of eight money collectors or men who had refused to contribute.

Not satisfied with targeting just Sheldon, Saltis now looked for Capone's weak spot. In February, his gang kidnapped Al's driver, going by the names Tony Ross and Rossi. His body was discovered in a suburban cistern after he had been gagged and tied up with wire; his fingers, toes, hands and feet were burned away to make him give up his boss's secrets. Finally, he was shot five times in the head. Whether Rossi had refused to talk or knew no secrets, Saltis gained nothing by the ghastly torture.

Around this time, U.S. Senator William McKinley accused Assistant U.S. Attorney James McDowell of letting a $9 million liquor syndicate operate between Chicago and the East. Millionaire whiskey-certificate broker Abraham Levin testified about how syndicate payoffs reached lofty places, but all names were withheld from the public. The homes of two stockyards district policemen were bombed to silence them, and no one in the liquor syndicate ever stood trial.

The moral chaos of the decade played into the hands of William Hale Thompson. But before he could return to city hall, he needed to overcome shadowy powers within his own party. Former adviser Fred Lundin was backing a bric-a-brac independent Republican for mayor. At his first campaign forum in April 1926, Thompson ambled onto a downtown theater stage with two caged rats. Speaking to one, he said, "I just want to address you, Fred, if it isn't true that I was the greatest friend you ever had?" This led him to discuss all the liquor spots Dever had shut down, and he vowed, "When I'm elected, we will not only open places these people have closed, but will open ten thousand new ones."

State's Attorney Crowe, a small man who had risen from crooked judge to career opportunist, became friendly with Big Bill again now that it was politically advantageous. To establish a base, the chief prosecutor put together a slate of judicial candidates answerable only to him. But his ambitions collapsed under disclosures that three carloads of North and South Side gangsters from the Hymie Weiss and Spike O'Donnell outfits were part of his political strategy. Then superior court judge Joseph David chastised the State's Attorney's Office for doing nothing about ninety-two gangland murders he said could have been solved and told an assistant prosecutor that "there has grown up a horde of blackmailers, hijackers, and manhandlers. Unless you [Crowe's office] dissolve the relationship between politics and crooked alcohol dealers, you won't solve the problem....The impression in this and other communities is that bootlegging is a noble profession." Nothing was done, because bootlegging *was* a noble profession.

Adding to his collection of corrupted suburbs, Capone reportedly sent a large number of "floaters" (repeat voters) to polling places in East Chicago, Indiana, where Mayor Raleigh Hale owned brewery stock. Capone also took sides in bloody bootleg gang battles in south suburban Chicago Heights, which saw a dozen murders in three months. One victim was strangled, soaked in alcohol and set on fire in a Chicago onion field.

Remaining in Cook County Jail for killing one of two policemen, Anselmi and Scalise were allowed to have Sicilian meals brought in by Scalise's

former landlady. In late April, he became so ill that he told his partner not to touch the food. Authorities determined that the spaghetti and beans contained enough cyanide to kill six men. Schedules were changed for a heavy guard to escort the gangland assassins to Joliet Prison for their fourteen-year manslaughter sentences.[68] Had a jail guard in the pay of a rival gang tampered with their food? And was it an attempt to keep them quiet, revenge for the cop killings or a hint that whoever was behind the poisoning could reach anybody? No one found out.

Four nights after the cyanide attempt, off-duty assistant state's attorney William McSwiggin climbed out of a sedan at the Pony Inn in Cicero on April 27, 1926, with Klondike O'Donnell men Thomas Duffy and James Doherty. Klondike and his brother had recently launched their own beer war by lowering their price from Capone's sixty dollars a barrel to fifty for a stronger brew of their own. But the men had been followed by a four-car Capone hit squad. A submachinegun poking out of one of the autos cut down all three, with McSwiggin possibly mistaken for Klondike.

Nearly every available officer from Chicago and suburban Cook County was put on the case because Cicero police showed no interest in arresting the perpetrators of the worst crime ever committed in their community.[69] The murder of a prosecutor, however unintended, became the impetus for private initiative. By May, the Chicago Crime Commission had received up to $500,000 in donations as seed money for a public and private effort to get around Crowe and police captains who were obstructing investigations. The group would later develop a "Public Enemies" list so that the public might scorn rather than envy mobsters. In the same spirit, Forest View vigilantes on Memorial Day 1926 roughed up a watchman and set fire to the Maple Inn, called "the Stockade," because it was Al's largest brothel and where his men sometimes hid out.

Newspapers shied away from detailing how gang activity was providing an unlimited supply of liqueurs to the Gold Coast. But then a lawsuit over an unpaid bill revealed Near North Side alderman Titus Haffa's involvement with a pricy liquor outfit. Wealthy Haffa employed chemists to make continual quality checks of the alcohol on behalf of his prosperous clientele, and any federal agent who tipped him off about a raid was thanked with $500 to $1,000.[70] An ex-representative for Haffa's operation testified in the civil action that the city council member had made inquiries about buying pardons. That was when the judge stopped him from elaborating.

As Washington, D.C. hearings into the unforeseen effects of Prohibition lasted into the summer, witnesses disclosed how some gangsters in Chicago

and other parts of the country came up with thousands of dollars in start-up funds. Former Los Angeles rumrunner William Davidson testified that he helped five western banks make deals with illegal liquor distribution networks. Similar arrangements were made with individual bankers east of the Rockies, including Chicago.[71]

Since gem salesmen in the gangland era lived in fear of robberies, the Jewelers' Building on the northern edge of downtown opened in 1926 with a guarded drive-in entrance leading to wide special elevators that carried locked autos to shops on the first twenty-three floors.

In late July, hoodlums from the newly combined Spike O'Donnell/Ralph Sheldon gang took aim at Frank McErlane's brother, Vincent, on the South Side but missed and killed a henchman. Saltis, already hating John "Mitters" Foley over a minor dispute, assumed the Sheldon gangster had been part of the assassination team. In the sunshine of an August afternoon, the dumpy mob leader climbed out of a Cadillac and pumped several bullets into Mitters in front of witnesses.

With the gang situation becoming more fluid, unknown gamblers dabbling in bootlegging reportedly encouraged Hymie Weiss to operate beyond the traditional North Side boundaries, which must have appealed to his capricious nature. Then oafish Saltis discussed with him the possibility of fixing his murder trial in the Foley case. He may have imagined that a merger of the North Siders with Saltis's stockyards gang would be strong enough to challenge Capone. All this was about to play a part in a Wild West–style shootout in the most fashionable part of downtown at the time.

The ethnically diverse North Side gangsters were to come up with $500,000 for a venture supposedly involving real estate but was probably a bribery scheme. Bugs Moran, Peter and Frank Gusenberg and three other men drove from the gang's flower shop headquarters on August 10, 1926, each bringing a portion to spread the risk. They climbed out at the nineteen-story Standard Oil Building on South Michigan Boulevard near the Art Institute. There they were met outside by Schemer Drucci, concealing more than $32,000.

Somehow four occasional members of the Capone gang had learned about the money trip and, acting on their own, waited in a car near the commercial tower, which contained the Sanitary District offices. The presence of Assistant State's Attorney John Sbarbaro, an ally of ambitiously corrupt Sanitary District trustee Morris Eller, in the building minutes earlier makes these goings-on even more suspicious. Sbarbaro dropped by the office of extravagantly corrupt Sanitary District president Timothy Crowe, unrelated to the state's attorney.

We are asked to believe that everyone's converging at the Sanitary District headquarters with all that cash was just a coincidence, so instead Sbarbaro may have visited Timothy Crowe to tell him how much his boss, Robert Crowe, was asking to fix Saltis's trial. Sbarbaro came down just as Drucci was talking with the others outside about having breakfast. As the four gunmen who had been waiting in an auto jumped out of their car, Weiss and Drucci slipped pistols out of their shoulder holsters and a lunchtime crowd scrambled for cross streets.

Drucci covered for his fleeing partners by repeatedly firing an automatic from a doorway and then behind a parked car, but the only casualty was a passerby grazed in the leg. Drucci threw his gun under an auto and rode the running board of a passing auto until officers yanked him off. They found the money he was carrying and named him on a weapons charge that was quickly dismissed by Eller's son, a judge.[72] That only seemed like the end of the matter.

Capone's wife, Mae, and their son lived at 72nd and Prairie in Chicago, but to keep them safe, Al had been staying for more than a year at the Hawthorne Inn across from the Subway casino. In the early afternoon of September 20, 1926, about ten autos slowly drove down Cicero's 22nd Street as Al and his bodyguard Frankie Rio were eating in the hotel restaurant, along with more than fifty others. Suddenly came the bark of a tommy gun firing blanks either to scatter pedestrians or draw Capone out, but Rio pulled his boss under a table.

Pistols shots from subsequent cars sprayed the building and shattered every ground-floor window. A man with a tommy gun, possibly Peter Gusenberg, came out of the next-to-last auto and knelt on one knee at the hotel entrance. He poured "a perfect barrage of bullets" back and forth over the heads of cowering patrons before jumping into the final auto. Only four people were wounded, three of them in a passing car. The *Herald and Examiner* screamed, "Smashing all precedents of gang warfare, a veritable battalion of death…descended upon Cicero yesterday." There is no proof who arranged the rolling armada, but Weiss's flair is evident. He may have wanted to serve notice about his new alliance with Saltis and force Al to give up the names of the Standard Oil Building shooters.

This unheard of "battalion" of death made it easier to prosecute those behind the town's moral putrescence. Cicero village manager Joseph Klenha and seventy others were named on alcohol conspiracy charges for sharing $15 million in illegal profits from Cicero gambling, liquor and prostitution ever since Capone's takeover two years before. A federal judge halted the

trial after two key witnesses were found dead. In all, at least ten witnesses who had been lined up for various gang prosecutions were killed that year, but there is no way of knowing whether any were murdered to obstruct justice, were shot in quarrels or were killed for an unconnected racket.

Now enter the dangerous Aiello brothers, who ran a North Side bakery and small restaurant and soon would be the greatest threat Capone ever had. The Aiellos increased their underworld influence by spreading resentment against Unione Siciliana president Tony Lombardo as being nothing but a Capone lackey. In early October, the Unione and the Weiss/Saltis outfit arranged a peace conference for all major gangs in the city. A newspaper told readers, "An important official and a policeman [possibly Stege?] sat in" on discussions at a Loop hotel. Capone had Lombardo represent him rather than risk a clash of tempers.

Drucci and the Aiellos seem to have accepted a cease-fire with the South Siders. But Weiss went further and demanded the names of the attackers at the Standard Oil Building. This led Lombardo to leave the talks and call Capone. Tony returned and said his boss refused. Hymie stomped out just as the late Dean O'Banion had done.[73] History was about to repeat itself and at the same place.

On the eleventh, Weiss watched jury selection in Saltis's murder trial. He later drove a short distance with splashy Saltis attorney William W. O'Brien. Their driver, Sam Peller, pulled up outside Holy Name Cathedral at State Street and Chicago Avenue, four months after the church drew thousands for a Eucharistic Congress, then the men headed for the flower shop across the street. They met up with Weiss bodyguard Patrick Murray and Maxie Eisen's bodyguard Ben Jacobson, an investigator for O'Brien. That might mean jury-fixer, in that Weiss was carrying $5,300; Murray had more than $2,100, and O'Brien was walking around with $1,500.

Their every move was observed from two nearby buildings. When Weiss stepped into range, there was an explosion of gunfire, with well-aimed pistol shots directed at Hymie as submachinegun spurts pelted the pavement and church bricks as his companions fanned out. Attorney O'Brien crouched behind a corner of the cathedral, but Weiss and Murphy died just twenty feet from where Dean O'Banion had been cut down in his shop. Capone neither claimed nor denied responsibility for the attack, but he did say, "The only people we have to fear is each other. There's plenty of business for all of us."

Tempers were so strained that another amity session was called. Opposing gang delegates agreed on general rules, such as that leaders would be held

Holy Name Cathedral a few weeks before Hymie Weiss was ambushed at the corner. *DN-0081730*, Chicago Sun-Times/Chicago Daily News *collection, Chicago History Museum.*

responsible for the actions of their men, perhaps a reference to the Standard Oil robbery attempt, and that all past shootings were now closed.

A few evenings after Saltis's bribed jurors freed him, the city had the most brightly lighted downtown in America when President Coolidge threw a ceremonial switch in Washington. Electric bulbs blazed along the one-mile length of State Street in the Loop. The $100,000 system was paid for by downtown businessmen and public benefactors still proud of their city.

With Weiss's death, North Side leadership fell to Bugs Moran, who had been given a hobo nickname for someone who goes crazy sometimes. Moran led without originality or sense of direction and would later cede authority to more ambitious members.

After a rash of gambling-related explosions, an alderman noted that some of the houses belonged to Morris Eller's enemies. In November, a bomb damaged the home of undercover policeman Thomas Garland after he had risked his life gathering evidence against a West Side whiskey operation. As the State's Attorney's Office tried to develop bombing ring member

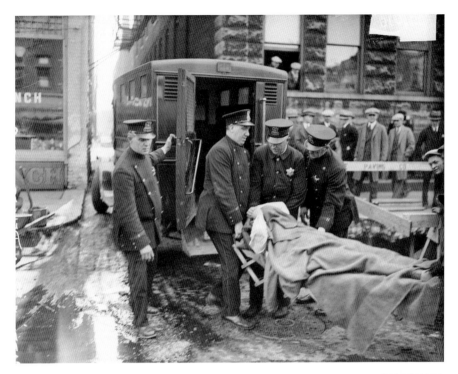

Hymie Weiss ambush victim Sam Peller's body being removed from the scene. *DN-0082096, Chicago Sun-Times/Chicago Daily News collection, Chicago History Museum.*

George Matrisciano into an informant, mobsters took him for a ride and the investigation dissolved.

The question by mid-decade was not where one could buy liquor in Chicago but where one couldn't. Locations included the county tax extension office in the city hall/county building and a speakeasy across an alley from the downtown police station.[74] Alcohol offenses were unpunished by local authorities, but no one was safe from federal scrutiny. Superintendent Collins's secretary, police captain John Prendergast and Judge Harry Walko were indicted for separate conspiracies to violate the Volstead Act. Walko had camouflaged his criminality by coming down hard on petty criminals while involved in a ring that used a policewoman as an alcohol runner.

By now, union violence was virtually expected. In November, gangsters killed Edward Dunn, Black vice president of the apartment building janitors union, as he rode a bicycle while police guarded his home. Although four officers happened on the murder, all three men they grabbed were acquitted because the jurors refused to trust the police anymore.

Weiss's parade of gunfire at the Hawthorne Inn was such bad publicity that hotel owner Theodore Anton changed its name to the Western and in late November tried to get rid of lowlifes loitering nearby. Though a friend of Capone, Anton was shot to death and his body pushed into the quicksand of a suburban canal bank as far as it would go.

Even Druggan and Lake's frequent vacations from the Cook County Jail touched on the secret criminal links binding the city together. Testimony showed that Thompson man Morris Eller had wanted to ingratiate himself with the two bootleg leaders, and he encouraged—paid?—Sheriff Hoffman to let them have outrageous privileges. Just how a federal jury found the obviously guilty Druggan and Lake innocent of traveling to restaurants and pleasure spots when they should have been in their cells came out a month later. Since a corrupt U.S. marshal and a deputy had been unable to plant a police captain's son on the jury, Joseph Delehenty from the horse-breeding hills near Elgin arranged to pick up the laundry of juror Walter Patterson, a neighbor. The wash came back with this message: "Terry Druggan is a friend of mine. Money."[75]

Hoffman was booted out of office that November, and his successor died of natural causes two weeks later. This opened an opportunity for casino owner Jack Zuta to take control of suburban law enforcement. With his sharp financial skills, the former brothel owner became a political fixer after shelling out thousands to keep his gambling house open. If we can trust the word of a woman jilted by a Chicago police sergeant, the Russian Jewish Zuta spoke of constructing a criminal-political alliance once Thompson returned to office.

In 1926, Zuta reportedly provided $50,000 of the approximately $260,000 Capone gave Thompson's campaign for the next year's election. Having bought himself into city politics as if purchasing a seat on the stock exchange, Zuta conveyed crooked lawyer Charles Graydon's interest in filling out the term of the expired sheriff. With Graydon's underworld links, he was supported by both Republican state's attorney Robert Crowe and Democratic county board president Anton Cermak. On December 27, county commissioners chose Grayson as sheriff by a vote of eight to four.[76] As Thompson might have said, the lid was off.

With Governor Small freeing every felon meeting his price, the year was ending as the legislature in Springfield worked on a bill that would transfer pardoning authority to a five-member board. Since Small would immediately veto any such legislation, the measure had to wait until a new governor was sworn in.

Folksy Anton Cermak before he was elected mayor. *DN-0080526*, Chicago Sun-Times/
Chicago Daily News *collection, Chicago History Museum.*

The seventy-five murders the Chicago Crime Commission counted as
gangland fatalities that year—despite a reform administration—made
1926 one of the bloodiest in the city's history until the spread of drugs and
proliferation of weapons in our time. Though still everywhere, drinking
was losing its fashionable cachet. For the first time in the "dry decade,"
some tables were empty at downtown nightspots on New Year's Eve after
managers signed a pledge not to sell or allow liquor that day. But patrons
arrived with pocket flasks and gurgling bags anyway.

1927-1928

Under newly installed sheriff Charles Graydon, slot machines, prostitution and liquor networks rapidly reached susceptible suburbs, and he appointed Northwest Side gangster and highway patrolman Matt Kolb as his special investigator.[77] Kolb's credentials? Political corrupter Jack Zuta evidently had relied on him to pass along $3,500 a month to police captains for letting him run his North Clark Street casino.

In early 1927, Theodore Anton's quicksand killers were afraid Cicero café owner John Costenaro might identify them. They got him drunk, bound him in a sack of sawdust and buried him alive in the loose earthen floor of an auto garage. Costenaro inhaled sawdust with every breath, leading the coroner to describe it as "a horrible death."

Nearly everyone in the city by now seemed somehow touched by the netherworld of outlawed alcohol. A Chicago couple and their teenage daughter died from fumes as they made moonshine at home. My father was shot at as he ran into a cornfield for trying to sell gangsters beer kegs that held mostly water. As a telephone operator in a downtown exchange one of my farm-bred aunts inadvertently heard Mayor Thompson discussing the possibility of cheating the Red Cross or Salvation Army. She and her sister lived in a building where a gangster had sexual fights with his girlfriend and sometimes went down the hall with her over his shoulder. Both sisters spoke about this forty years later as a high point in their lives.

"The time has come when no one is free from gang danger," Captain John Stege claimed in a *Herald and Examiner* series. "More than 50 murderers

roam the streets of Chicago. All of them are vicious; most of them are cowards." He said Joe Saltis had offered him $5,000 to lose documents and later boasted, "I had them lost, in spite of you. The case was dropped; it cost me $10,000."

Although in 1920 the Illinois Republican Party had refused to slate Thompson because of his criminal contacts, in 1927, Cook County Republican chief Homer Galpin saw how Big Bill's criminal connections might enrich the party. With Galpin's guidance and support from Capone and political conniver Jack Zuta, Thompson easily won the nomination on his two-faced pledge to "end crime and gang rule in Chicago."

In March, mentally disturbed Frank McErlane was acquitted of murdering an Indiana lawyer on impulse, but the stockyards gang he returned to had been falling apart ever since Hymie Weiss's murder ended its brief alliance. In February, the police grabbed Saltis's no. 2 man Frank Koncil in a foot chase and pressured him to talk. But his gang caught up with him in traffic, and he died as more than forty shots were traded between cars.

Gamblers were important moneymen in all Prohibition rackets, but long-standing methods for rigging horse races offered quicker returns. The Illinois Racing Association ignored flagrant practices, such as the midnight crippling of horses with a crowbar, until the public demanded stricter regulations. In 1933, half a dozen Chicago gamblers would be charged with bribing a stable owner, a jockey and two exercise boys to "drench" (drug) a total of eleven horses at the Arlington Park racetrack in the suburbs.

Now that Thompson had won the Republican mayoral nomination, county Democratic Party chairman George Brennan planned a landslide for the unobtrusive incumbent. As he put it, "Mayor Dever will be re-elected [because] this is a white man's town." Not even the KKK ever made such a statement in Chicago. Apparently to show what Dever could do in a second term, police rounded up one thousand African Americans on slender pretexts on Saturday, March 9, 1927, and all were released without charges that Monday.

Brennan hired African Americans to appear unkempt and ring doorbells in Caucasian neighborhoods, then be obnoxious as they asked occupants to sign a fake Thompson pledge card. Whites were hired to telephone acquaintances about selling their homes before "a Negro invasion" followed Thompson's return. Democratic workers bombarded the "colored section" with anonymous letters urging them and their friends to meet Thompson about an important matter at his hotel campaign suite on the afternoon of April 1, leading to an April Fool's Day rush to downtown.[78] Dever became

so hated by liberals that even Illinois attorney general Oscar Carlstrom and U.S. Senator Charles Deneen declared support for Thompson.

The day before the election, police routinely picked up racketeers to keep them from the polls. Trigger-tempered North Side gangster Vincent Drucci was killed in a struggle with gangster-hating Detective Dan Healy while being driven to a bond hearing at his own request. The next day saw the usual citywide voting violence. An election judge was killed; Gold Coast alderman Dorsey Crowe was kidnapped by gamblers and told to lay off raids; and state senator Lawrence O'Brien was threatened with death after his Near North Side headquarters were bombed.

No one was surprised when voters embraced Thompson's return. With all the murders and heists going on, Police Commissioner William O'Connor's first crackdown was on pickpockets. Big Bill then paid off campaign debts by weakening the undermanned police department, such as using a manufactured excuse for getting rid of honest Captain Stege. When Stege was later hired back under public pressure, he was assigned to an empty station until the newspapers learned about it.

A youthful band of robbers, for some reason known as the "42 Gang," started getting noticed when members such as Sam Giancana started killing witnesses whom they could not bribe. Despite receiving little attention at the time, the gang and other ruthless robbers would form the core of the Chicago crime syndicate in the 1930s.

Limitations in federal laws meant that for years, tax crackdowns were little more than an inconvenience. But in May 1927, the U.S. Supreme Court held in the case of a southern bootlegger that taxing unreported income did not violate self-incrimination protections. Again jumping ahead, when the tax agency was transferred to the Justice Department in 1930, enforcement became more systematic and aggressive. Future governor Dwight Green and others in the Chicago division of the U.S. Attorney's Office made sense of a plethora of criminal reports on Al and Ralph Capone by developing the "net worth" theory of prosecution, using their lavish spending as proof of undeclared profits.

The eight Aiello brothers decided to breach the Capone truce and offered a cook at the Little Italy Restaurant in Cicero $35,000 to lace his food with prussic acid. On May 28, 1927, the cook supposedly weakened and notified Al, perhaps hoping for a thank-you of more than $35,000. Later that night, hundreds of bullets were fired into the Aiello bakery and small restaurant on West Division Street, wounding two people, to show that "Scarface Al" was very much alive and in control.[79]

The brothers realized they had greatly underestimated Capone. As a fly sees the slightest movement because of thousands of receptors, his network of eyes included newsboys, cab drivers, ambulance attendants, hospital workers, waiters, switchboard operators, policemen and others who knew he would pay handsomely for tips. Perhaps this was how he later learned that the Sicilian bakers had put a price on his head eventually reaching $50,000. Al placed Jack McGurn in charge of eliminating anyone enticed by the offer, leading to a May–September rash of at least eleven killings among Italians, some newly arrived from out of town as well as two Capone underlings.

Underscoring that anyone could turn bootlegger, Methodist minister Thomas Turner of the exclusive South Shore neighborhood was sentenced in July to nine months in jail for operating a liquor cutting plant, and police sergeant Grover Heidelmeier was charged with needling beer at his licensed brewery. The complicity of the police citywide was joked about, with Capone's plant on West 13th Street protected by off-duty officers in autos and on motorcycles.[80]

You never knew where you might come across crimes. In September, police discovered that pumps at a filling station in orderly suburban River Grove were hooked up to underground tanks filled with alcohol instead of gasoline, and a pipe led to a private home.[81] In addition, there remains suspicion among sports fans that the September 1927 fight in Chicago between heavyweights Jack Dempsey and Gene Tunney had been fixed, mainly because of the infamous "long count" while Tunney was down. Tunney won by a much-booed decision.

One of the best speakeasies in town in terms of jazz and conviviality was the gangster-owned Green Mill Gardens at the lively North Side corner of Lawrence and Broadway. Nightlife reporter Sally O'Brien saw a number of gray-haired men with flappers and peroxide blondes there and a well-groomed man sipping a cocktail under a table. A woman had passed out, and a couple was giving kissing lessons to their friends.[82]

In November, singer and comedian Joe E. Lewis, presently doing a gig at the Green Mill, was awakened in his Continental Hotel room by a telephone caller saying in a South Side accent, "Don't open da door—fa *nobody*." A little later, Lewis did just that and two mobsters pommeled him. Then one ripped his face from ear to throat with a hunting knife.[83] Jack McGurn biographer Jeffrey Gusfield reports that the attack was a personal matter between Lewis and North Side gangster Ted Newberry. The performer recovered with extensive rehabilitation, but his career was never the same again.

Several days later, police arrested five Aiello men setting out to dynamite a place where Unione Siciliana president Tony Lombardo was staying under Capone protection. The bakery brothers next tried to use assassins, but each time they were thwarted by Al's spy network. His information led police to a "machine gun nest" in a flat across from Lombardo's home.

After Joseph Aiello was picked up for a minor offense, his wife, accompanied by their young son, signed for his bond at the detective bureau, but he was afraid to leave because three Capone men had been seen loitering in the alley. Chief of Detectives Schoemacher ordered him to go home, and a lieutenant volunteered to drive the family to safety. That is *all* that happened, but several accounts have blown this night into fantastic proportions. Two newspapers and several books would have you believe that two dozen gunmen surrounded the place, although the Loop building had policemen entering and leaving at all hours, and all activity was visible from streetlamps and spillover lighting along America's most brightly illuminated street.

As usual, patrons at one of the better nightspots, the Parody Club on North State Street, saw on their table linen a card reading "The responsibility rests with you," an invitation to bring their own liquor. The nightclub was one of those scouted out by young women in the Edward Cummings robbery gang. On December 5, 1927, Cummings and two other gunmen entered the dance floor and fired twice into the ceiling to make the two hundred diners and dancers back away. But eight plainclothes officers, tipped off by a former member, popped out of hiding, and "guns seemed to blaze from every corner," a paper said. The reckless police gunplay led to the death of a waiter and the wounding of eight patrons. Cummings had his shotgun blown away from his hands before the police dragged him away.[84]

As the year ended, the stock market was on an upswing, but in Chicago, violence was still the fastest track to wealth. Citywide murders for whatever reason had jumped from 134 in 1918, before Prohibition, to 309 in 1927.

With the Aiellos on the defensive and Moran's North Side gang limping along without Weiss, Capone presided over a tightly organized criminal corporation through franchises and suburban takeovers. Journalist and publisher Cornelius Vanderbilt Jr., writing in *Liberty* magazine, called the outfit "the most perfectly oiled machine this country has ever seen."[85] It included dancers, chefs, physical trainers, labor terrorists, brewery managers, speakeasy front men, wiretappers, bodyguards and killers.

The year 1928 saw the rise and fall of a spectacular holdup gang headed by Charles Cleaver. They pulled off an $80,000 bank job and a $100,000 mail car dynamiting before five members were arrested. Cleaver and other

inmates escaped by walloping a DuPage County Jail guard in June with a stocking holding a can of condensed milk. Their waiting car was equipped with a tommy gun and shotguns. Thirty Chicago officers closed in on a Melrose Park farmhouse where they were hiding for an hourlong battle. Police tossed their empty submachineguns aside and used handguns until additional ammunition drums could be brought in. When it was over, Chief of Detectives Michael Grady called the fight "the most spectacular thing I have ever seen in my entire police career."[86] Cleaver and a second man were found to have a combined fifteen entrance and exit wounds, but both survived.

After taking care of would-be claimants of the Aiello bounty on Capone, Jack McGurn made sure his wife and young daughter were safe in the Near North Side's McCormick Hotel (now the James). But in March 1928, two men generally believed to have been Bugs Moran gunmen Peter and Frank Gusenberg entered the lobby and let loose with a pistol and tommy gun. McGurn ducked behind a wall but was wounded twice. After his attackers fled, he was able to make it up the elevator to his room, and the hotel physician phoned for an ambulance. A widely repeated newspaper fabrication had the former boxer followed in traffic and then shot in a lobby phone booth.

That month, federal agents entered the Chicago plant of the Hazel-Atlas Glass Company, made a few arrests and closed down the largest still ever discovered in Chicago, a massive $100,000 system of copper cookers and curling pipes capable of producing 4,500 gallons of alcohol in a day. No one was paying attention to worse crimes that were being committed against the greatest threat to the good times: change.

THE PINEAPPLE PRIMARY

Stakes were high for the April 1928 primary and ward committeemen races because of gangster ties enjoyed by several candidates. The white politicians needed to reduce the voting strength in two new areas in the black belt, the South Side Fifth Ward and the mostly West Side Twentieth Ward. In the Fifth Ward, a bizarre combination of police officers and gangsters had dispersed a peaceful meeting of Black voters against a Thompson-backed candidate. And in a turnabout, labor racketeer "Diamond Joe" Esposito campaigned for relatively honest candidates because he needed U.S. Senator Deneen's support in a fight against a man backed by State's Attorney Crowe. Bad decision. In March, both of Esposito's bodyguards

apparently blocked his escape, and he was cut down with a shotgun. A witness was killed the next night.

On March 26, bombs "of terrifying power" presumably arranged by Thompson exploded five minutes apart at the homes of Deneen and his choice for state's attorney. This labeled the period "the pineapple primary," although no grenades were used.

Elusive political criminal Morris Eller plotted to take over the Twentieth Ward, formerly the Nineteenth, because it now encompassed the Jewish "ghetto," Little Italy and part of the black belt. With the incumbent alderman supported by the Municipal Voters League, winning the Republican ward committeeman spot was crucial for increasing Eller's influence in the Thompson organization. Standing in his way was Octavius Granady, a Black lawyer campaigning for the same post.

Prosecutors would charge that on election eve, Eller told his men, "If anybody gets in your way, push them out of it. You can get guns at Johnny Armando's house if you want them. Don't be afraid. You've got the governor [Small], the state's attorney [Crowe], and the sheriff [Graydon] with you. I'll take care of the police—and if you need him, you've got a judge," Eller's son. A witness reported that a pair of election workers then showed up with two packages of Luger automatic pistols from Eller's car.

Granady acquaintance John H. Jackson would testify that on election morning, an Eller precinct captain told African American campaign workers, "That big-headed friend of yours [Granady] won't be around any more after 5 p.m." During the day, numerous people using stolen ballot blanks worked "the ring system" of multiple voting for Eller and allied politicians. After Dineen people were abducted and pistol-whipped, Granady pleaded with the senator's staff to start protecting Twentieth Ward polling places. But they declined. Dineen would sadly admit, "We were, although we did not know it, sending him to his death." As a car with Judge Eller and several gunmen drove around, one of the passengers called out to some Black women, "Get off the street before the machine gun goes off and blows you away!"

The polls closed at 4:00 p.m. An hour later, that car and one or two others followed an auto containing Granady and a couple of his election people. At 13th and Blue Island, men in the trailing cars fired four times and the Granady auto struck a tree. Eller men jumped out of the pursuing autos, and one of them hopped onto Granady's running board for a clearer shot with his tommy gun. The candidate was ripped up, and one of his supporters fled, blinded in one eye. Testimony suggests that arriving police did something to cover up elements of the assassination, if only to pick up Eller handouts at

the scene. When all the ballots were counted—those turned in and those that had been kept back—Eller won by just over 50 percent of the vote.

Four county commissioners backed by State's Attorney Crowe obstructed an appropriation to investigate all the election violence. Aging attorney Frank Loesch started his own inquiry with donations from banks and the public. A special grand jury indicted state senator James Leonardo and nine Eller men for kidnapping and assaulting election workers. Granady murder suspect Sam Kaplan was named on four counts of attempted murder in those attacks. But witnesses in the separate Granady case were intimidated with a bomb, an axe and blackmail threats. Then a judge refused to accept the eyewitness testimony of a Black man because he had voted more than once for Eller's slate. Loesch's giving another witness cab fare home was termed a bribe, and he was called senile. After more than a year of prosecutions, all of the accused were acquitted, and Chicago turned into a city of dreadful night.[87]

Capone may have thought the Aiello war over the Unione Siciliana had ended, but the North Side bakers were preparing for another push. In June, they killed two Capone men at Death Corner. Next, Frankie Yale, president of the New York branch of the Unione, was blasted with a tommy gun while driving home in July, possibly for backing Joseph Aiello as president of the Chicago branch. An unconfirmed report claimed Al had obtained authorization for the hit at a meeting in New York to make sure there would be no objection from Mafia boss Giuseppe Masseria and Lucky Luciano. Two weeks later, Capone men severely wounded an Aiello bodyguard with a shotgun downtown, then killed Joseph's brother Dominic.

Labor racketeer and former state representative Big Tim Murphy was gunned down outside his Far North Side home that summer for possibly trying to force himself into the cleaners and dyers union, now protected by Bugs Moran. A witness met death in front of a West Side hotel. But Mayor Thompson slashed an appropriation for more police in the increasingly honest force. They would only get in the way.

In late July, Capone moved from the Metropole to the Lexington Hotel on South Michigan, and before long, several bodyguards escorted aging reformer Frank Loesch there for a social call. Loesch told Al, "I want you to keep your damned Italian hoodlums out of the election" in November and do something about the violent "micks." Capone replied, "I'll have the cops send over the squad cars the night before the election and jug all the hoodlums," without mentioning that they already did this. Loesch left feeling he had accomplished something.[88]

At this time, the Aiellos plotted an ambush for Capone stand-in Tony Lombardo of the Unione Siciliana. On September 7, 1928, he left the Unione offices with two bodyguards, one of them believed to be in the pay of the baker brothers. He was shot down by men in a gangway at 61 West Madison, near one of the busiest corners in America. The second bodyguard was seriously wounded.[89]

In October, the Saltis gang used a tommy gun on Spike O'Donnell's home for trying to take over a portion of the stockyards. Later that month, Saltis torturer George Darrow fired a tommy gun at Spike near 63rd Street. The target saved himself by leaping to the pavement. Before long, Darrow—believed to have killed Capone driver Tony Rossi—was shot down when he threatened the police with a shotgun.

As shown by Capone's reportedly receiving permission for the Frankie Yale killing, interlocking self-interests among mob leaders in major cities were leading to discussions for an interstate criminal network. In November 1928, the twenty-three mobsters arrested in a Cleveland hotel came from Tampa, Brooklyn, Newark, Gary, Chicago and St. Louis. But Lucky Luciano did not give up the dream and still made strategy visits to the Windy City.

A rash of south suburban bootleg violence occurred while friction increased between Capone and Moran over a laundry drivers local Bugs protected. A Capone man's murder in November was balanced by the fatal shooting of a Moran foot soldier, and both sides girded for more clashes.

Also that November, newly elected Sanitary District trustee Henry Berger documented the agency's recent uncontrolled spending. Shortly after Timothy Crowe stepped down as the district's president on January 1, 1929, he would tell a special grand jury that the district had put sixty state lawmakers on the payroll as bribes. A Sanitary District trustee who agreed to testify had his home bombed twice.[90]

The Sunday before New Year's Eve 1928 saw more than one hundred couples dancing before dawn at the Granada Cafe by 68th Street. Shots erupted, killing bootlegger Hugh McGoven and, incidentally, pipefitters union business manager William McPadden in front of their shocked dates. Sheldon hitman George Maloney was nabbed as he joined the exit crush. McGoven's was the seventy-second and final gangland killing of the year, including robberies and Chinatown violence.

III

RECLAIMING THE CITY

6

1929

On New Year's Day, State's Attorney John Swanson swore in a special grand jury to look into ways the Chicago civic structure was steeped in crime. Prosecutors claimed the operators of approximately seven thousand "beer flats" were paying the police and politicians more than $10 million to stay out of jail.[91] No estimate could be made for bribery from speakeasies.

The Unione Siciliano war between the Aiellos and Capone continued without letup. Aiello gunmen killed Capone man Pasquale Lolordo before he could succeed murdered Tony Lombardo as head of the Unione, and mobster-friendly police captain Daniel Gilbert made sure no one was charged. Next, someone fired at Bugs Moran and a friend from a moving car as they left a gangster-owned nightclub, wounding the gang leader in the leg. The gunfire may have been Capone's response to the Lolordo killing or involved the dyers union, which Al wanted to take over.

The next day, dopey-looking but honest Louis Emmerson was sworn in as governor, and the era of selling pardons ended. Presumably there was no connection, but gangs were becoming less sweeping and more satisfied with what they had. But despite national prosperity, Mayor Thompson warned that the city could soon be bankrupt. In January, financially astute attorney Silas Strawn offered himself as someone "without political ambitions" to turn municipal finances over to a citizens committee that would seek donations from reputable persons with a stake in the city. And so, for a few months, Chicago dodged what could have been an economic disaster.[92]

Early in February, Alderman Titus Haffa, a Thompson man, pleaded guilty to taking part in a $5 million Gold Coast "rum ring" and was sentenced to two years in federal prison. But that did not presage a new era—Chicago was so far from reform that its violence was about to draw global attention.

Some men have history thrust upon them, and so it was with George Moran. His small, loosely disciplined outfit was no competition against Capone's tightly ordered super-gang, even after Bugs threw in with the Aiellos. Moran seemed more interested in union takeovers and selling protection (extortion) than in hooch. In fact, the gang was not even his anymore. Observers said that abrasive Jack Zuta did the thinking, ambitious Joseph Aiello was the financier and Moran's main function was to provide muscle and political bribes.[93] Bugs used a repair garage at 2212 North Clark as one of several drop-off points for liquor shipments. The small brick structure still bore the name of a former occupant, the SMC cartage company. If most of the front window had not been painted over, passersby on February 14, 1929, would have seen one of the most terrible moments in city history.

As Capone relaxed in Florida sunshine, the temperature in Chicago was around fourteen degrees amid a light snow. Moran biographer Rose Keefe said gang members going to the garage expected to confer with Bugs for the first time since he was wounded. The two Gusenbergs were the only full-time bootleggers. Auto repairman and former safecracker John May worked on an auto in his coveralls as the others sat around him. These men were landlord Adam Heyer; bank robber James Clark (Albert Kashellek); optometrist Reinhart Schwimmer, a mob hanger-on; and round-faced Albert Weinshank, who resembled Moran and looked after his boss's interests in the cleaners and dyers union.

A stolen green Cadillac similar to a police touring car pulled up in back. Moran was late returning from a haircut, and when he and an underling saw the suspicious car, they kept walking and missed what newly elected State's Attorney John A. Swanson would call "a holocaust of horror." A pair of men in police uniforms ordered the seven to raise their hands and face the wall. Three men in suits and topcoats came in, and the five cut everyone down with an automatic pistol, a shotgun and two submachineguns.[94]

All the victims died at the scene except Frank Gusenberg, who reportedly told the police before succumbing, "Nobody shot me." Unknowns about the St. Valentine's Day massacre include whether the fake cops had set out to kill everyone or overreacted when something happened. Among the theories for their being there are that the killers had mistaken Weinshank

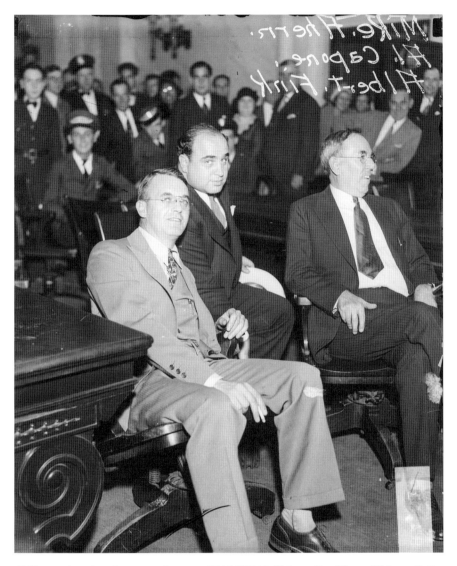

Al Capone (*center*) and attorneys in court. *DN-0097010*, Chicago Sun-Times/Chicago Daily News *collection, Chicago History Museum.*

for Moran, or maybe Weinshank was targeted so Capone could take over the dyers union. Or maybe Jack McGurn had set up the massacre to get even with the Gusenbergs for the hotel shooting. Or Capone wanted revenge for the Tony Lombardo and Pasquale Lolordo murders over the Unione. But nothing proposed over the years fits all the circumstances.

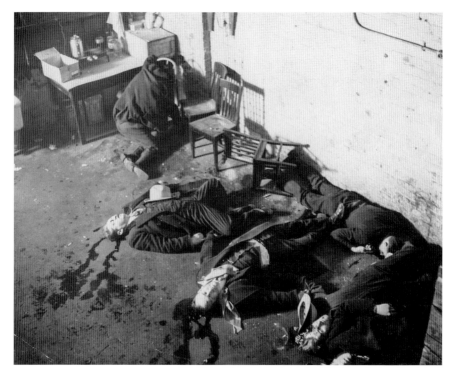

The St. Valentine's Day Massacre victims. *Chicago History Museum, ICHi-014406; Jun Fujjta, photographer.*

Certainly no one at the time speculated a North Side versus South Side gang rivalry, a later fabrication of newspapers and early Capone writer George Murray.

Since none of the seven victims seems to have recognized the fake policemen, they may have been members of Capone's "American boys" or recruited from outside Chicago. With gangster-accommodating police captain Daniel Gilbert called in to lead the investigation, no evidence was found at the scene. The coroner pointed out that of the 216 gangland killings in Chicago, the only perpetrator convicted of murder was "Sam" Vinci, who had been grabbed by a handful of witnesses as soon as he killed a witness at an inquest.

Claims that the massacre led to a public demand for action are exaggerated; the mass shooting actually had less effect on citizens than the McSwiggin killing. But the massacre crystallized everything the public imagined about the city's "beer gangs." An inquest jury was startled at being told the bodies would offer "the fingerprints" of the assassins—that is, side-by-side striations

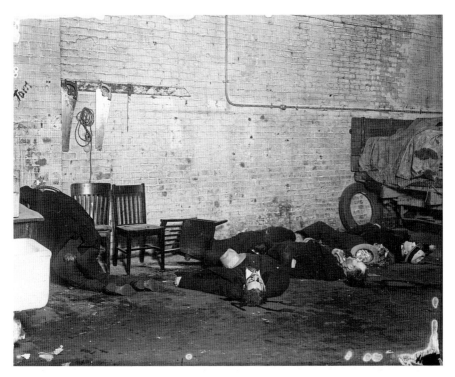

Inside the North Side repair garage after the Saint Valentine's Day Massacre. *Chicago History Museum, ICHi-061382; Jun Fujita, photographer.*

from a comparison microscope developed by self-trained criminologist Calvin Goddard. He had recently set up the world's first crime laboratory in the basement of a Chicago businessman.

An abiding image of Prohibition Chicago is of criminals going around with tommy guns in violin or viola cases. But the only instance that reached the newspapers came in March 1929, when two youthful robbers posed as musicians to get close to a banker transporting gems on a train rolling along the Far South Side. After one bogus player pulled a tommy gun from his case, the other grabbed the diamonds and they jumped off the train with a warning shot.[95] Yet except for high-profile cases, law enforcement was working again.

A drug-addicted labor racketeer in the Klondike and Myles O'Donnell bootleg gang shot an oil company executive in a quarrel at Cicero's Pony Inn, scene of the McSwiggin killing. Mob-controlled village manager Joseph Klenha told his men not to make a report, but county highway patrolmen arrived and closed the roadhouse down.

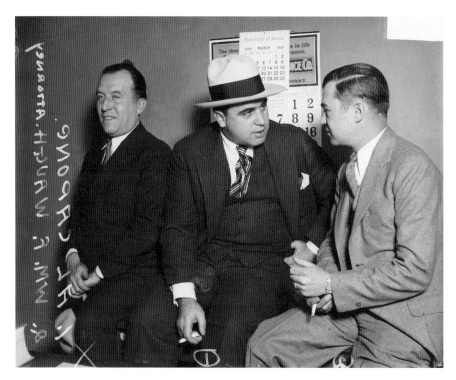

Al Capone talking to his lawyers. *DN-0087660,* Chicago Sun-Times/Chicago Daily News *collection, Chicago History Museum.*

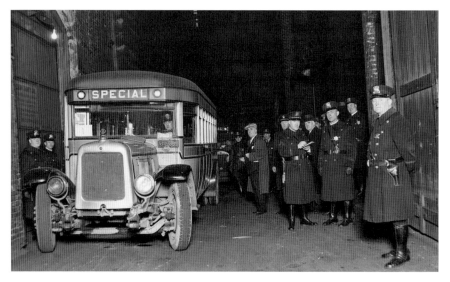

Police about to transfer prisoners to the new county jail in 1929. *DN-0087864,* Chicago Sun-Times/Chicago Daily News *collection, Chicago History Museum.*

Unable to fight off larger gangs, the two Cicero/West Side brothers semiretired from the rackets, the first gang to fold in the next couple of years. There must have been a growing feeling among gangsters that they could no longer do as they pleased. The new spirit was seen in May, when hitman George Maloney was actually convicted of the New Year's Eve nightclub shooting of Hugh McGoven over stockyards control. One of the jurors had told the others, "If we let him go, he'll keep on killing."

Even the days of quick getaways were ending. Shortly after the North Clark Street massacre, RCA engineers wired a low-frequency communications system in the police section of the new Municipal Building at 12th and State, about a block from a major Capone brewery. Eventually, this let the detective bureau broadcast alerts to roving squads and helped cartoonist Chester Gould create Dick Tracy while riding around with officers for research.

Forty suburban women stormed into State's Attorney Swanson's office in April to demand action against Capone's plans for taking over Stickney at the polls. When Swanson did nothing, reformers mounted an opposition that defeated Al's candidates, and state's attorney's police responded to public pressure by chopping up all gambling equipment in town. But Capone won out anyway by arranging for a former roadhouse front man to be named Stickney police chief. On May 1, federal indictments were returned against eighty-one people from a Chicago Heights liquor ring that Capone had helped along.

The war over the Unione Siciliana ended with a new legend in violence. When Joseph Guinta rose to president of the social and political organization, he shut out Capone influence and chose as his vice president former Genna assassin John Scalise, released from prison early after taking part in the killing of a policeman. But on May 8, 1929, their bodies and that of Scalise's murder partner, Anselmi, were found in a car and a ditch near the 139th Street tracks. Nearly their every bone had been broken before they were finished off.

It seems that a waiter at a north suburban restaurant had relayed to Capone's people that Anselmi and Scalise spoke to Joseph Aiello, possibly about the $50,000 bounty for Capone's death. At the same time, John Torrio from New York was trying to reach accord between Capone and Aiello so he could submit an undivided city to organizers of a possible national crime federation.[96] According to the *Chicago Tribune*, Bugs Moran, Torrio and Joseph Aiello would go along only if Anselmi and Scalise were eliminated, for they were a threat to everyone.

Evidence shows that Guinta and the two others went to dinner on May 7, 1929, at a roadhouse called the Plantation between Burnham, Illinois, and Hammond, Indiana. The *Tribune*, prone to fabrication at the time, said they had been lured there and greeted with kisses of brotherhood and that the only other persons present were their four executioners. Several accounts elaborate on this and say the beatings started after Guinta, Anselmi and Scalise enjoyed a full meal and plentiful wine. From this grew the legend that the dinner was a banquet in their honor and Capone personally beat the three men with a baseball bat or Indian club. There is no evidence to support any of this, and Al may have even been out of town.

With the shocking triple murder behind him, Capone attended an Atlantic City meeting with mobsters from New York, Philadelphia, Detroit, New Orleans, and Kansas City. Along with the advantages of collaboration, they may have discussed investing in nightclubs, casinos, real estate and legal breweries as a financial cushion now that public opinion was turning against Prohibition. As a local consequence of the session, North and South Side liquor distribution networks were merged under Capone, and the Unione presidency went to Joseph Aiello.[97]

Following the Atlantic City conference, Capone was arrested in Philadelphia for weapon possession and spent a year in a prison cell that resembled a dormitory room. His criminal enterprise continued in his absence with the guidance of financially astute Jake Guzik and rising mobster Frank Nitti. But as an indication that the political-criminal weave no longer held, State's Attorney Swanson's investigator Pat Roche shut down Capone's Gold Coast casino and then went after his thirty other "resorts" one by one.

Any offense could now land a hoodlum in jail. In August, Anthony de Giovanni was so surprised at being convicted of transporting a bomb that he tried to leap out a fifth-floor window of the new courthouse at 26th and California, and seven Southwest Side policemen were hauled before a judge for beating prisoners. But several stalled prosecutions spurred the private sector into making positive changes. Chicago Association of Commerce president Robert Isham Randolph denounced Mayor Thompson's reign as "the most corrupt and degenerate municipal administration that ever cursed a city....There is no business, not an industry, in Chicago that is not paying tribute, directly or indirectly, to racketeers and gangsters."[98]

Randolph asked for help from the Prohibition office, now under the federal Bureau of Investigation. One of the best men at the Chicago office had been Alexander Jamie, but he made one raid too many and was forced to quit.

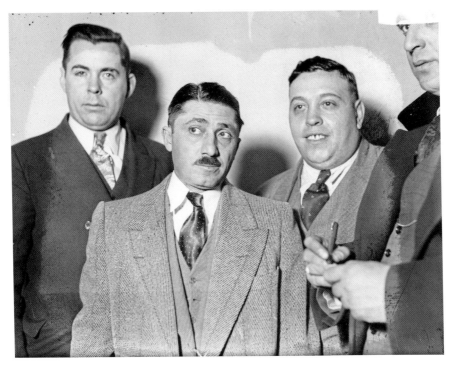

Al Capone's ruthless successor, Frank Nitti (*second from left*). *DN-0093637*, Chicago Sun-Times/Chicago Daily News *collection, Chicago History Museum.*

For a special assignment, Jamie recommended his brother-in-law Eliot Ness, who then led a band of agents a newspaper called "The Untouchables" that used a truck to crash into breweries. Even so, Ness was unable to get anything against major criminals.

A decade of prosperity had left investors unprepared for market instability, resulting in an October 29 panic in which millions upon millions of dollars were lost on the New York stock market without any effect. A day after the crash, police riot squads had to break up an angry swarm in front of the Chicago Board of Trade.

On November 1, Terry Druggan and Frank Lake were indicted for income tax fraud, and "Machine Gun" Jack McGurn was framed on a charge of violating the Mann Act by going to Miami with Louise Rolfe, his "blonde alibi" in the massacre. In another attack on crime, state's attorney police raided Cicero's largest remaining casino and took three hundred people into custody. Yet crime remained rampant. When robbers with a tommy gun herded diners into a recess at an Elmwood Park restaurant, the owner produced a hidden one of his own. This led to what a newspaper

called a "duel of machine guns," but no one was hurt, and the bandits roared off.

Ineffectual Bugs Moran could not stop a falling out between fellow leaders of the North Side gang: bootleg thug Ted Newberry and political manipulator Jack Zuta. After a few quarrels, Newberry believed he could compel Gold Coast casino operators to switch liquor suppliers on his own and was severely wounded by one of them or a member of his own gang as he drove near the Green Mill. But despite the St. Valentine's Day massacre, the Chicago Crime Commission's gangland murder count for 1929 actually dropped to sixty-four. This did not mean mobsters were less violent. It meant there was now virtually only one gang in town.

7

1930–1933

H umorist Will Rogers wrote in a column for January 9, 1930:

Just passed through Chicago. It's not a boast, it's an achievement. The snow was so deep today the crooks could only hit a tall man. To try and diminish crime, they laid off six hundred cops. Chicago has no tax money. All their influential men are engaged in tax-exempt occupations [crime]. *What they got to do is tax murder. Put such a stiff tax on it that only the higher class gangsters can afford it. It's the riff raff that makes any business disreputable.*[99]

Many people fondly recalled that "Mr. Capone" helped the needy from a South Side soup kitchen in the Depression, unaware that the food had been donated to the city and surreptitiously diverted. Far from benevolent, the Capone super-gang managed to cheat most Chicagoans through its man in the Thompson administration, city sealer Daniel Serritella. In charge of butcher scales in those days before meat packaging, Serritella took sizable bribes to allow short-weighing that possibly cost customers more than $54 million a year.[100] After his acquittal, Serritella took a seat in the state senate with gangland support.

The Chicago Crime Commission was so disgusted by the city's lack of response to serious crime that it recommended firing every policeman on the force.[101] On February 21, a jobless army of more than one thousand men and women, possibly stirred up by communist agitators, made three

surges against the doors of city hall. Each time, they were driven back by 150 policemen. Mayor Thompson made no statement about the social crisis outside and may have been in one of his alcoholic retreats.

After gangster Ben Bennett spatted with Bugs Moran, he and John Rio, not to be confused with Capone bodyguard Frank Rio, joined Capone's outfit. In February, both men were kidnapped, tortured, shot and had weights tied around them. Rio was dropped into the North Branch of the Chicago River, and Bennett was flung into the Sanitary and Ship Canal. Reports that some mob victims were dropped into Lake Michigan are unsubstantiated.

As shown by the Stickney protesters, women were speaking out. Elizabeth Barnard was so upset over the murder of one of her husband's employees in a union takeover attempt that she implored him to do something about it. Harrison Barnard discussed the problem with the head of the Chicago Association of Commerce. The official then asked five civic leaders if they would raise crime-fighting funds. The result was an anonymous group, informally called the Secret Six, that directed large sums to specific investigations, such as $75,000 for the Revenue Bureau to pile further evidence against Capone.[102]

There was now sometimes little difference between mobsters and private citizens. A Black jazz band driving to a west suburban roadhouse in February killed two white men who kept cutting them off and trying to cause trouble. This and other shootings that month led the *Herald and Examiner* to observe that "about the cheapest thing in Chicago is human life."[103]

With the gradual dissolution of the Joe Saltis stockyards gang, the wife of henchman John "Dingbat" Oberta goaded him into forcing his way into a union representing sports ushers for 20 percent of their paychecks. Before long, Oberta was killed by Saltis assassin McErlane. Frank then became mixed up in a minor shooting and was taken to a hospital with a bullet-fractured leg that was put in a cast and suspended on a trolley. Two men walked into his private room on February 24, 1930, and fired three times before he could grab a gun from under his pillow. The mobsters ran out, leaving him for dead. The four policemen who should have been guarding Frank were immediately transferred. But this was not an instance of gangland warfare; the would-be killers had been hired by McErlane's girlfriend, Freda. But he forgave her, married her and later shot her to death in their car during a fight. By then he was out of control.

Released from the Philadelphia prison, Capone at thirty-one had reached his peak of fame and influence. On March 24, he graced the cover of *Time* and had an average of ten illegal breweries operating at any given time.

Al was interviewed by national magazines, and newspaper publisher Cissy Patterson praised his manliness. But in April 1930, a jury accepted the net worth prosecution of his brother Ralph and convicted him of tax fraud. He would be sentenced to thirty years in prison. Al must have known the end was coming.

Several citizens, including an off-duty judge and an outraged butcher, started doing undercover work for the police, the butcher at the cost of his life. Violence even reached a bootlegger recreation spot in the far north suburban Chain O' Lakes region. During a nighttime party on June 1, 1930, glass of an enclosed porch shattered, and within seconds one hundred bullets exploded from a pistol and a submachinegun. Killed in the unsolved assault were teamsters slugger Michael Quick; Sam Pellar, an "election terrorist" from Morris Eller's ward; and former North Side safecracker Joseph Bertsche. A high time–seeking woman and Terry Druggan's robber brother, George, were wounded. On June 3, a striking blonde lured gangster Thomas Somneria of Morris Eller's political/criminal network from his room, only for him to be bound and garroted for no known reason. Maybe he wanted to talk about the Granady murder or his bosses didn't like his fronting for a McGurn restaurant.

The *Chicago Tribune* employed Alfred "Jake" Lingle as an embedded underworld tipster, not really a reporter. He went around hangouts picking up rumors and engaging in lucrative side rackets. On June 9, 1930, someone fatally shot him at close range in the back of the head as he and others were hopping down the outside stairs of a downtown train station. Lingle may have been killed for interfering with an upscale North Side casino Moran protected. Or taking money from Jack Zuta without arranging dog racing for him at the Chicago Stadium. A suspect was convicted but seems to have been a fall guy. The books are still open on the murder of Capone's south suburban alcohol czar Lorenzo Juliano, who may have been dispatched with a sledgehammer.

Savvy Capone managed to break up the wobbly North Side gang by inducing Ted Newberry to go after personal pursuits. This allowed Al to isolate Jack Zuta before the political fixer could form an alliance with the likely next mayor, county board president Anton Cermak. Zuta was brought in for questioning about some matter in July, then after dark, a police lieutenant and a patrolman protecting him in a detective bureau car shot it out with gangsters along the blazing lights of State Street. With one gunman firing from a window of the sedan, another kept shooting from the running board while Zuta and his two-man police escort fired back. Some

bullets crashed through streetcar windows. The unknown gangsters fled by throwing a smoke bomb to conceal their direction. But Zuta's deliverance did not last long; he was killed with submachineguns a month later while in hiding at a Wisconsin lodge as several couples danced near him.

With almost all of the North Side gang dead or joining rivals, Moran rounded up gunmen around his boyhood haunts in Minnesota. His new outfit made headlines by killing three members of a Kansas City/St. Paul robbery gang trying to hijack its liquor trucks. Moran then had his men settle in Chicago one by one in warmed-over hopes for a partnership with the Aiellos.

By now, newspapers seldom mentioned Mayor Thompson, strongly suggesting that he had given up leadership in his bouts of drinking and perhaps depression. In July, the city council made its disdain clear by passing a new ward map that reduced the voting strength of the South Side black belt, his power base, and heightened the voting power of the affluent Near North Side.[104]

After information about the Moran-Aiello gang reached Capone, an Aiello man was shot to death in a North Side apartment. Fearing for his life, Joseph Aiello fled to where he thought Capone would never find him: the apartment of a friend, West Side retailer Pasquale Prestogiacome. For ten days, Aiello refused to step outside and used the time to arrange a trip to Texas by phone. As Aiello was about to take a cab for the train station on October 23, Prestogiacome locked the front door and Joseph was felled by the spray of two tommy guns as he begged to be let in. Like the Druggan and Lake gang, like the Sheldon and Klondike O'Donnell gangs, the once powerful Aiello outfit was no more and the North Side gang was in tatters.

Chicago Police sergeant James McBride expected to testify against William "Three-Fingered Jack" White for the 1925 murder of a suburban policeman. But the day before Halloween 1930, a man believed to have been Capone ally Claude Maddox boarded a crowded streetcar and fired a shotgun into his face. McBride recovered while guarded by five officers but was unable to testify. With jurors now harder to bribe, White was convicted anyway and sentenced to serve fourteen years.

In November, voters replaced Capone-backed Sheriff Graydon with one-armed Democratic former alderman William Meyering, who was supported by Northwest Side/north suburban mob chief Roger Touhy. "I am not a reformer," Meyering admitted. "I do not intend to become one." A special grand jury submitting a report on Chicago lawlessness contended on the day before Thanksgiving that the city was dominated by a de facto "super-

government"—an overwhelming conspiracy of criminals and politicians—
"costing the taxpayers not only uncounted millions in money, but it is seriously
jeopardizing the security, happiness, and very lives of the citizenry."[105]

Capone's claustrophobic "enforcer" Frank Nitti pleaded guilty to federal
tax charges on December 30, 1930, and would be sent to Leavenworth for
eighteen months. Capone financial expert Jake Guzik was given a five-year
term in the same prison. The year had seen sixty-four gangland deaths.

The C&O Cabaret on the Near North Side was like most other dining
and drinking places celebrating the new year of 1931. But as patrons flung
confetti and paper serpentines, three gunmen came through the door and
snatched $2,000 of their cash and jewelry. But a patron, possibly future
Syndicate boss Sam Battaglia, reached for a robber's gun and suddenly
bullets were flying everywhere. Battaglia was wounded, and a wounded
policeman ran outside after the bandits. He shot two of them, but they lived.

Conniving Democrat Anton Cermak won the mayoral election in
April because the public was unaware of his criminal intentions. Since
Thompson had arranged for federal Prohibition agents to leave Black-
managed cabarets alone during his terms in office, police in the new
administration threw two thousand people into disorder that month in
sweeps at the Panama Inn, El Rado, Ritz Cafe, Pleasure Palace and Grand
Terrace. White cabarets were spared.

In May, state's attorney's police carried away gambling paraphernalia
from Spike O'Donnell's casino near 78th Street. He had initiated the city's
violent bootleg era in 1923 but was now scraping for money to keep former
Chicago gang leader Ralph Sheldon from being convicted of kidnapping a
Los Angeles bookie. Spike stole $100,000 from his brothers, thereby ending
the gang.[106] Corpulent and illiterate Mike "de Pike" Heitler, who had pulled
off the whiskey caravan double-cross of 1920, was so sure he was about to
die for selling information about mobsters that he dictated a letter naming
his likely killers. In May, his body was found in the smoldering ruins of a
suburban icehouse as just one more still-unsolved gang murder.

What was evolving into the Chicago crime syndicate gained power partly
through its cozy relationship with the State's Attorney's Office, as shown by
at least five witness-murders related to just the Calumet City liquor trade in
1931. Some victims were killed near the office, and another was shot and
stabbed as his two young children slept in the same room.[107]

Independent mobster Roger Touhy and former state's attorney chief
investigator Matt Kolb thought they had the Northwest Side and northern
suburbs to themselves as they made inroads to the new administration. But

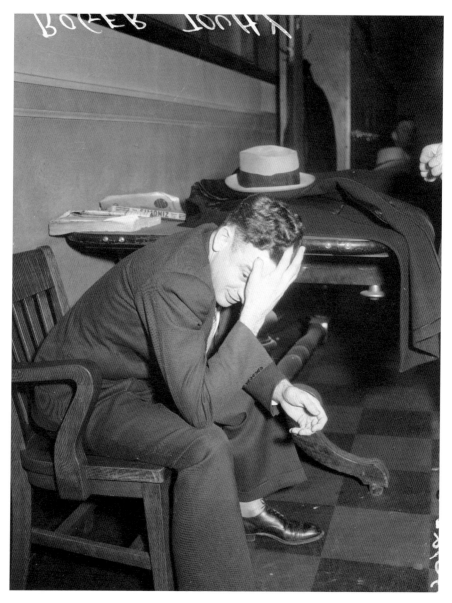

Northwest Side mobster Roger Touhy caught in a bad moment, perhaps after being framed for a kidnapping that never happened. *DN-A-5250*, Chicago Sun-Times/Chicago Daily News *collection, Chicago History Museum.*

carloads of Capone/Nitti men led by bodyguard Frank Rio and robber Claude Maddox then entered the forbidden zone in early May and declared "a new deal." Touhy's killing a Syndicate man did not stop Maddox from going to all forty-one Kolb resorts over the next month and supervising the replacement of his slot machines with the Syndicate's.

Honest police chief Rocco Passarella of the corrupted Chicago suburb of Melrose Park was fired for telling a grand jury about liquor operations in the community. He was rehired on public insistence only to be kidnapped in June and shot down as he tried to run. All this time, the federal government kept building prison walls around Al Capone.

In addition to his tax charges, he and sixty-eight members of his operation were indicted in June 1931 for wholesale Volstead violations. Capone pleaded guilty four days later, giving himself time to concentrate on the more serious income tax counts. In the face of the government's encyclopedic evidence, he initially pleaded guilty to these charges as well. But Al angrily changed his mind in July, when U.S. District Court judge James Wilkerson placed all twenty-three counts relating to bootleg profits under the "Jones 5 and 10 Law," which allowed a penalty of five years in prison and a $10,000 fine for each count.[108] After nine hours of deliberation, on October 17, 1931, jurors returned with a headline-splashing verdict of guilty. Capone was sentenced to eleven years in prison.

Frank McErlane's behavior had become even more alarming. He would drive around shooting at imaginary enemies and jabbering about people out to get him. After being freed in the murder of his wife, he fell off the gangplank of a rural houseboat his friends had arranged for him on the Illinois River and died of pneumonia. The year had seen just forty-eight gangland killings. Most of the bootleg rubouts were to eliminate witnesses and maintain the shrinking liquor business.

Several gangsters killed a union official in January 1932 to take over Moran's cleaners and dyers brotherhood. As with Judge Lyle, crusader Frank Loesch blamed the union takeovers and gang murders on corrupt judges, calling them nothing but "cash registers." But unions and liquor did not account for all the rubouts. Independent bootlegger Abe Cooper was shot to death over a bond deal that month. His partner was found hiding, killed and his body shoved into an empty beer barrel to be left in a suburban vacant lot.

Chicago women played less a part in the times than in the early 1920s, except in sports and as matriarchs and social leaders. Newspapers were now featuring fashions for figures that were more mature than out-of-style flappers, and an authority calling herself "Prudence Penny" went around

Chicago giving talks about how Depression-era women should open jobs for men by staying home.

Voters early that year ended the fifteen-year tenure of Cicero's complacent village manager Joseph Klenha. But before residents could enjoy the peace, the home of new manager Joseph Czerny was bombed in April. When the police went to the Western Hotel (the former Hawthorne) to question Capone's brother Albert about it, a desk clerk remarked that he could not believe officers were now actually investigating gangland crimes, but no one was charged.[109]

After living in an enjoyment culture for most of Prohibition, Chicagoans now wallowed in a death culture. The vibrant Mary Margaret Collins was drawn to men living on edge, and one by one all eight at the time of her notoriety were killed by the police or gangsters, supposedly including Dean O'Banion, taxi union terrorist Eugene McLaughlin and airborne liquor smuggler Irving Schlig. In 1932, the "Kiss of Death Girl" was seen nightclubbing with future no. 9, Gus Winkeler, possibly one of the St. Valentine's Day gunmen.

Whipped up by Cermak's people, Democratic conventioneers in Chicago virtually ended Prohibition by nominating Franklin Delano Roosevelt for president. Influential national figures were already calling for repeal because of the terrible consequences. But after the ballyhoo of hosting both national conventions in the same summer, Chicago seems to have lost some of its energy and distinction. The Windy City had seen too many bad mayors and police chiefs and prosecutors, and exhaustion was setting in.

Capone had not bothered with small-timers, but when Nitti was released from prison in March 1932 and took over the Syndicate, he was brutal with any independence, such as killing a saloon owner in August for offering beer at thirty-five dollars a barrel. Beside one of two men killed for trying to start a small beer business were a siphon hose and gunny sacking for concealing barrels on an open-bed truck.

Times were changing, but not by much. State's Attorney John Swanson had been expected to restore responsibility to his office, but he was caught wiretapping a phone Secret Six investigator Alexander Jamie was using in a probe of the office. Later Swanson's office would be accused of taking at least $650 a week to fix local-tax cases and of squeezing liquor dealers for campaign contributions.[110] Then after a police guard was withdrawn from the 45th Street home of anti-gang Judge John McGrooty in September, a bomb hurled from a passing car exploded too soon, permanently blinding a sixteen-year-old boy walking by and disfiguring his girlfriend.

"Kiss of Death Girl" Mary Collins. At least eight of her boyfriends were killed one at a time. *DN-A-2911* Chicago Sun-Times/Chicago Daily News *collection, Chicago History Museum.*

A Democratic sweep in November 1932 elected Roosevelt and emboldened Mayor Cermak to announce that unapproachable Pat Roche would be dropped as chief investigator for the State's Attorney's Office. The new chief prosecutor, speakeasy investor Thomas Courtney, chose crooked policeman Daniel Gilbert as Roche's successor to restart the criminal alliance with the courts.

In December, a small band of robbers held up a pair of downtown mail clerks and fled with $500,000 in cash and checks. Involved in the planning was wealthy Edgar Lebensberger, a Ted Newberry front man in a Gold Coast speakeasy-casino. Before he could be indicted, Lebensberger was shot to death in a suicide or, more likely, murder in his Lake Shore Drive home, one of the best addresses in the city.

Cermak laid a foundation for actively using criminals as a behind-the-scenes power source, such as packing his personal police detail with rough, undisciplined men. He sent two of them along with two honest officers for a harassment arrest of Nitti and whoever was with him at a downtown

meeting. When the four policemen threw the door open, Nitti supposedly shoved some foolscap into his mouth. In a struggle to get it out, one of Cermak's officers, Harry Lang, shot the gang boss behind the right ear and through the right lung, barely missing the mob leader's spinal cord. To justify the action, Lang wounded himself in the left arm, and someone falsified the report.

At the time, Newberry was involved in several politically protected Near North Side casinos. Nitti suspiciously assigned "Kiss of Death" boyfriend Gus Winkeler to look for any shady financial accounting, and Newberry started drinking more because he knew his time was nearly up.

The 1932 count of gangland murders ended at thirty-two. On December 31, mounted policemen had little trouble keeping order among Loop celebrants on what many believed would be the final New Year's Eve of Prohibition. Nightclubs were charging only five to ten dollars for dinner, with unlimited ginger ale as a champagne substitute. As a reflection of how gangs had gone mainstream, the Morrison's packed dining room had someone called Hotel Baby 1933—one imagines it was a little person in a diaper—"shoot" Old Man 1932 and be dragged away by busboys to cheers and noisemakers.

The end came for Newberry on January 7. He was kidnapped, shot three times and rolled into an Indiana ditch. Nitti might have given the order, but Newberry had made a lot of other enemies as well. Winkeler quickly took over his casinos and even moved into his late friend's suite on Lake Shore Drive. He must have been unnerved when Nitti assigned killer Ralph Pierce to watch over him, as Winkeler had watched over Newberry.

As champion of the city's huge anti-Prohibition faction, Mayor Cermak was already a part of national Democratic politics. Who knows how far he might have gone, but a bullet went through his lung as he shook hands with President-elect Roosevelt in Miami's Bayfront Park on February 15, 1933. The police immediately seized an anarchist who shouted against everyone in authority. By the time Cermak succumbed to his wound on March 6, newspapers had turned him into a martyr. Many people still believe that rather than a presidential assassination attempt, the act had been revenge for Nitti's wounding. The Bohemian mayor's criminality surfaced only gradually, such as the discovery of a strongbox containing nearly $1 million despite the city's hobbled finances.[111]

Nitti's trap-like mind could not stand the thought that someone else controlled the Northwest Side and northern suburbs. But he wanted to avoid a territorial war. A murky element now emerged in the form of Jacob

Factor, half brother of cosmetics king Max Factor. The once barely literate barber had pulled off a British stock swindle and was staying out of reach in Chicago's Gold Coast. Afraid that deportation would cost him everything, Factor asked Nitti for help, and the astute gang leader saw this as a way of eliminating Touhy without bringing the administration down on them.

In July 1933, police announced that Factor had been kidnapped for a $200,000 ransom as he left a Morton Grove roadhouse. Captain Daniel Gilbert, the mob's man in the State's Attorney's Office, summoned the police chiefs of twenty suburbs and told them to seize every member of the Touhy gang even though there were no indications Touhy had been involved. In fact, evidence years later would show that the abduction never happened. Looking shabby after several days of disappearance, Factor identified himself to a suburban LaGrange policeman and said, "Get me a cab." Touhy would be convicted of kidnapping, sentenced to ninety-nine years, escape, be rearrested and be exonerated in 1959, only to be shot to death presumably by Chicago mobsters. The reason is still unclear.

Cermak had built the city's modern Democratic machine, but with him gone no one was sure who was in charge. By city ordinance, the fifty aldermen were to choose a mayor from among themselves. After dithering, the councilmen received state permission to pick an outsider: colorless, look-the-other-way Sanitary District chief engineer Edward Kelly. At last, the criminal interests had a puppet mayor.

The glitter of the city's 1933 World's Fair, called a Century of Progress, was diminished by several murders in robberies and union takeovers. Since all North Side gang leaders were dead except for Bugs Moran, who had formed a new group with Minnesota bruisers, the new head was Gus Winkeler, who had never been a bootlegger. He had learned street life with Egan's Rats in St. Louis, gained experience with the notorious Purple Gang of Detroit and was one of Capone's American boys. Under him, the gang held up an armored truck and engaged in other dangerous robberies in Chicago and beyond. With two accomplices, Winkeler killed a policeman while speeding from a downtown mail robbery. He was arrested but allowed to remain free, since he was feeding information to the Secret Six before the group fell apart.

On October 9, someone fired seventy-two shotgun pellets at Winkeler as he walked toward his North Side beer distribution company. A priest administered last rites in a hospital before he died, the sixth North Side gang leader shot to death, following Reiser, O'Banion, Weiss, Drucci and Newberry. No other criminal organization in the city's history has had nearly

as high a mortality rate. Winkeler also was the last major Chicago gangster killed during Prohibition.

Mayor Kelly insisted from time to time that there was no organized gambling in Chicago. One of those nonexistent gamblers and casino operators, Harry Wheeler, was having his nails polished at a barbershop in November when a gunman hired by a rival sneaked behind a partition and killed him with four shots. After that, the streets quieted down.

Prohibition ended at 4:31 p.m. on December 5, 1933, when Utah joined other states that had ratified repeal. A bellhop made one of the local announcements by ringing a bell as he walked to the bar at the Hotel Sherman. Soon women made up about a third of patrons in lines at all downtown hotels, gazing again at real bottles of wine, bourbon, gin and whiskey being brought in by armful and crates.

Skyscrapers that had gone dark for the evening lit up office by office as off-duty employees returned with bottles to laugh the evening away with coworkers, and people celebrated around Loop theaters. Police gave up trying to keep vehicles moving through the heedless humanity. Since bartenders took too long mixing cocktails, many sophisticated customers ordered their drinks straight, and jostling queues became six deep. Empties were discarded onto jangling heaps near back doors. In drugstores, counter clerks dispensed liquor bottles with one hand and grabbed money with the other.

Giddy imbibers handed panhandlers more money than usual, and happy crowds sang "Sweet Adeline" and other songs as boozing outlasted the dawn. For that one night, the Depression was suspended as a bloody epoch died along with the most hated law in America. In bidding farewell to the Jazz Age, F. Scott Fitzgerald said he and all others who had been young in those wild times "will never feel quite so intensely about our surroundings any more."[112]

The Chicago Crime Commission counted 737 gangland murders during Prohibition, from 1920 to 1933. By the end of the period, Chicago had squandered its spirit. Yet by the mid-1930s, police and the courts were less corrupt, and the justice system in general was working again. Violence would continue—with "Three Fingered Jack" White killed for talking to investigators, cowboy poseur Louis Alterie shot to death leaving his apartment and Jack McGurn slain in a bowling alley—but it was no longer entwined with politics.

The era is all dust and wind now. It is easier to walk among ancient ruins than it is to find reminders of Prohibition in Chicago, the city where the

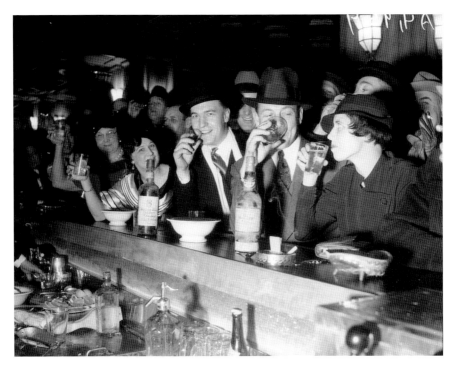

A La Salle Street bar at the end of Prohibition. *DN-A-4954*, Chicago Sun-Times/Chicago Daily News *collection*, *Chicago History Museum.*

times had been maddest. Most of the South Side that bootleggers died over has undergone a racial change, and few 1920s sites remain, apart from some downtown office buildings. The Green Mill is still a jazz club, but the site of the St. Valentine's Day massacre was demolished in 1967, and the North Side gang's flower shop is now a parking lot. Yet a mystique remains. In northern Indiana, they tell of Chicago bootleggers who buried troves of liquor or cash in Ali Baba–like caves sealed with dynamite, and fortunes are waiting to be discovered.

My family and everyone they knew had lived in a time like no other, and they brought all its evils upon themselves.

NOTES

Introduction

1. "The Age of the Rum Runner," *Chicago Tribune*, June 17, 1934.
2. Doherty, "I Remember," *Chicago Tribune*, February 4, 1951.
3. *Time*, January 30, 1928.

1. 1920

4. Nelli, *Italians in Chicago*, 121.
5. Kobler, *Capone*, 56–58.
6. *Chicago Herald and Examiner*, July 11–14, 1927; February 20, 1930.
7. Peck, *Prohibition in Washington*, 126
8. *Chicago Tribune*, January 22, 1920.
9. *Chicago Tribune*, August 29, 1920.
10. McPhaul, *Johnny Torrio*, 30–31.
11. Bilek, *First Vice Lord*, 234–37; *Chicago Tribune*, May 15, 1920; December 14, 1920; December 17, 1920.
12. *Chicago Tribune*, October 3, 1932.
13. *Chicago Tribune*, March 24, 1929.
14. Stuart, *Twenty Incredible Years*, 95–105.
15. *Chicago Herald and Examiner*, April 11, 1927.

16. *Chicago Tribune*, October 3–6, 1920; *Chicago Herald and Examiner*, October 4 and 25, 1920.
17. Schoenberg, *Mr. Capone*, 54.

2. 1921–1923

18. *Chicago Herald and Examiner*, January 22, 1926.
19. *Chicago Herald and Examiner*, August 10, 1931.
20. Riddings, *Len Small*, 46–48, 139; *Chicago Herald and Examiner*, July 5 and 9, 1921.
21. Lombardo, *Black Hand*, 40.
22. *Chicago Herald and Examiner*, April 12, 1927.
23. *Chicago Herald and Examiner*, April 14, 1927.
24. *Chicago Herald and Examiner*, May 12 and 13, 1921.
25. *Chicago Herald and Examiner*, May 21, 1921.
26. Riddings, *Len Small*, 165; Grossman, *Political Corruption in America*, 405.
27. Jackson, *Ku Klux Klan*, 93–95; Philpott, *Slum and the Ghetto*, 183; Chalmers, *Hooded Americanism*, 181; Rice, *Ku Klux Klan*, 18; Gillette and Tillinger, *Inside Ku Klux Klan*, 33; *Chicago Tribune*, August 16–17, 1921; Anonymous, *Ku Klux Klan*, 40; *Chicago Herald and Examiner*, September 15, 1921.
28. *Chicago Herald and Examiner*, September 25 and 29, 1921.
29. *Chicago Herald and Examiner*, December 21, 1921.
30. Details of liquor manufacturing follow the James O'Donnell Bennett series in the *Chicago Tribune*, February–March 1929, with some information from Lesey, *Murder City*, 208.
31. Doherty series, *Chicago Tribune*, February 4, 1951.
32. *Chicago Herald and Examiner*, November 17, 1921.
33. James O'Donnell Bennett series, *Chicago Tribune*, March 3, 1929.
34. Len Small photos, Keefe, *Man Who Got Away*, 117; Riddings, *Len Small*, 94–97, 125–26; *Chicago Tribune*, March 1, 1923; April 22 and 29, 1923; May 13, 19 and 26, 1923; June 5, 1923; September 3, 1923; October 2 and 23, 1923.
35. Jackson, *Ku Klux Klan*, 97–107, 108, 110 and 268; Chalmers, *Hooded Americanism*, 180; Wade, *Fiery Cross*, 187–88; and Irey, *Tax Dodgers*, 24; *Chicago Daily News*, April 2, 1923; *Chicago Tribune*, January 19, 1923; April 8, 1923.
36. *Chicago Herald and Examiner*, March 7, 1923.
37. *Chicago Herald and Examiner*, September 20, 1922; January 23, 1923; March 13, 17 and 27, 1923.

38. *Chicago Herald and Examiner*, September 18, 1923; February 15, 1929.

39. *Chicago Herald and Examiner*, July 8, 1923, and September 19, 1923.

40. *Chicago Herald and Examiner*, April 16, 1927.

41. Jobb, *Empire of Deception*, 210.

3. *1924*

42. "Car Men's Ball Killing," *Chicago Tribune*, February 4, 1924; Kissane's acquittal, and a side notation in the Chicago Crime Commission list of gangland killings.

43. Cicero before Capone, *Chicago Herald and Examiner*, November 13, 1924; Masters, *Tale of Chicago*, 312, and *Chicago Tribune*, November 20, 1920; McPhaul, *Johnny Torrio*, 184; the election, *Chicago Tribune*, April 1, 1924, and *Chicago Herald and Examiner*, April 2 and 4, 1924; how Cicero welcomed Capone, *Chicago Tribune*, July 4, 1926; "certain beer territories," Lyle, *Dry and Lawless Years*, 83.

44. *Chicago Herald and Examiner*, August 25, 1930.

45. *Chicago Herald and Examiner*, July 5, 1928.

46. Reverend Williams's disclosures and his home being bombed, *Chicago Tribune* and *Chicago Herald and Examiner*, both on April 29, 1924.

47. *Chicago Daily News*, May 9, 1924; Barzini, *Italians*, 246–48.

48. Bergreen, *Capone*, 131–32; Keefe, *Guns and Roses*, 182; *Chicago Tribune* and *Chicago Daily News*, both on May 19, 1924, and *Chicago Herald and Examiner*, May 20, 1924; Druggan and Lake disappear after the raid, *Chicago Herald and Examiner*, June 17, 1924.

49. Gottfried, *Boss Cermak of Chicago*, 151.

50. *Chicago Tribune*, September 6, 1931, and September 21, 1932.

51. *Chicago Tribune*, July 24, July 30, and August 9, 1924.

52. *Chicago Herald and Examiner*, September 27, October 25 and November 5, 1924; December 9, 1927.

53. Keefe, *Guns and Roses*; Torrio negotiating with O'Banion and the dispute over the Genna debt, *Chicago Tribune*, July 4, 1926, and Peterson, *Barbarians in Our Midst*, 126.

54. *Chicago Herald and Examiner*, January 25, 1927.

55. *Chicago Herald and Examiner*, February 3, 1925.

4. 1925–1926

56. Petranek, "All Capone's 1928 Gangster Car"; Pasley, *Al Capone*, 77–78; Kobler, *Capone*, 128.

57. McPhaul, *Johnny Torrio*, 212–14; *Chicago Herald and Examiner*, January 27, 1925; Torrio's court appearance after the shooting, *Chicago Herald and Examiner*, February 10, 1925.

58. Cook County Jail scandal, *Chicago Herald and Examiner*, February 22, 1925; *Chicago Tribune*, February 1, June 6 and September 19, 1925.

59. Police station selling liquor, *Chicago Herald and Examiner*, March 7, 1925; Judge Comerford's complaint, *Chicago Tribune*, March 24, 1925.

60. Bergreen, *Capone*, 119–21.

61. Burrough, *Public Enemies*, 365; the Genna doctors, *Chicago Tribune*, June 16, 1925; Helmer, *Al Capone*, 162–63.

62. *Chicago Herald and Examiner*, May 26, 1925; August 2, 1925; June 15, 1925.

63. Kobler, *Capone*, 149–50; *Chicago Tribune*, March 3, 1929; Schoenberg, *Mr. Capone*, 131; Keefe, *Guns and Roses*, 177–78; Collins's reaction to the killing of four officers, *Chicago Herald and Examiner*, June 14, 1925; arming police squads, *Chicago Tribune*, June 14, 1925.

64. *Chicago Tribune*, June 17–18, 1925.

65. Message on the church door, *Chicago Tribune*, March 24, 1929, Lyle, *Dry and Lawless Years*, 36; Wigmore, *Illinois Crime Survey*, 611.

66. Bullets thrown into the air, *Chicago Herald and Examiner*, September 12, 1925; Sam Vinci at the inquest and sentencing, *Chicago Tribune*, February 26, 1926.

67. Yenne, *Tommy Gun*, 67–68.

68. *Chicago Herald and Examiner*, April 23 and May 4, 1926.

69. Primarily from the *Chicago Tribune*, April 28, 1926.

70. Irey, *Tax Dodgers*, 21–22.

71. *Chicago Herald and Examiner*, June 16, 1926.

72. *Chicago Daily News*, August 10, 1926; *Chicago Tribune*, August 11, 1926; *Chicago Herald and Examiner*, January 21, 1927; Kobler, *Capone*, 175–76; Schoenberg, *Mr. Capone*, 158.

73. October truce talks: *Chicago Daily News*, giving the location as the Hotel Sherman, October 8, 1926; *Chicago Herald and Examiner*, giving the location as the Morrison Hotel, October 10 and 12, 1926, and April 19 and November 23, 1927; Kobler, *Capone*, 177–80; Weiss murder, *Chicago Tribune* and *Chicago Herald and Examiner*, both on October 12, 1926; Keefe,

Man Who Got Away, 195–98; Capone's response to the killing, *Cosmopolitan* interview, excerpted in the *Chicago Herald and Examiner*, March 9, 1927.

74. County building liquor, *Chicago Herald and Examiner*, November 7, 1926; rolling beer by the police station, *Chicago Tribune*, June 1, 1929. (For raids near the city hall and county building, see the *Chicago Tribune*, June 12, 1929).

75. *Chicago Herald and Examiner*, December 8, 10 and 18, 1926; *Chicago Tribune*, December 9 and 18, 1926.

76. *Chicago Daily News*, December 3, 1927; *Chicago Tribune*, December 18, 1927; *Chicago Herald and Examiner*, January 18, 1931; Riddings, *Len Small*, 167–68.

5. 1927–1928

77. Zuta's business acumen, *Chicago Tribune*, April 13, 1931; using Kolb as bagman, *Chicago Herald and Examiner*, August 19, 1930.

78. Schmidt, *May Who Cleaned Up*, 160; massive raids in the black belt, *Chicago Herald and Examiner*, March 10, 1927; Carlstrom and Deneen support Thompson, *Chicago Herald and Examiner*, March 18, 1927; Brennan's racial strategy and "a negro invasion," Stuart, *Twenty Incredible Years*, 304–5; *Chicago Herald and Examiner*, April 2, 1927. Even my father told me about this.

79. Aiello poison plot, *Chicago Tribune*, November 22, 1927, and September 8, 1928; the May 28 bakery attack, *Chicago Tribune*, June 17, 1927, and January 5, 1928; Keefe, *Guns and Roses*, 217; Schmelter, *Chicago Assassin*, 113–14.

80. *Chicago Tribune*, June 13, 1931.

81. *Chicago Herald and Examiner*, September 9, 1927.

82. *Chicago Herald and Examiner*, April 21, 1927.

83. Cohn, *Joker Is Wild*, 18; *Chicago Herald and Examiner*, November 9, 1927.

84. *Chicago Herald and Examiner*, April 18 and December 6, 1927.

85. *Liberty*, October 17, 1931.

86. *Chicago Tribune*, February 27 and 28, 1928; *Chicago Herald and Examiner*, June 15, 1928; *Chicago Tribune*, March 3, 1929.

87. The Pineapple Primary: pre-primary bombings, *Chicago Tribune*, March 27, 1928; Belcastro's bomb trust, *Chicago Herald and Examiner*, April 10, 1929, and *Chicago Herald and Examiner* and *Chicago Tribune*, both on August 1, 1929; the Lugers, *Chicago Tribune*, November 1, 1928;

Jackson's testimony, *Chicago Tribune*, October 26, 1928; stuffing ballot boxes, *Chicago Tribune*, May 18 and October 23 and 27, 1928; kidnapping poll workers, *Chicago Tribune*, October 19 and 28, 1928; Watts and Brown beatings, *Chicago Tribune*, October 23 and 24, 1928; "sending him to his death," *Chicago Tribune*, April 11, 1928; "before the machine gun goes off," Johnson's testimony, *Chicago Tribune*, October 26, 1928; the Granady murder, *Chicago Herald and Examiner*, April 12 and October 31, 1928; *Chicago Tribune*, April 11, October 11 and November 1, 1928; Riddings, *Len Small*, 29–31, 235–41; that Hough lost an eye, *Chicago Herald and Examiner*, June 22, 1928; Rufflin testimony, *Chicago Tribune*, November 28, 1929; policemen watch election beatings, *Chicago Tribune*, July 12, 1928; "city of barbarism," quoted in the *Chicago Tribune*, March 29, 1929; the 713 ballots, *Chicago Tribune*, July 31, 1928; a 50–50 vote, *Chicago Herald and Examiner*, February 26, 1929; the investigation stalls, *Chicago Herald and Examiner*, June 1 and 14, 1928; Leonardo and Kaplan indictments, *Chicago Herald and Examiner*, June 19, 1928; two attempted attacks on Hough, *Chicago Herald and Examiner*, June 22, 1928; the county board rejects the allocation, *Chicago Tribune*, June 9, 1928; Judge Eller lowers bonds and the CBA statement, *Chicago Tribune*, July 20, 21 and 26, 1928; Granady witness Johnson threatened and the Sephus assault, *Chicago Tribune*, October 27, 1928; Brown's hush money, *Chicago Tribune*, October 23 and 24, 1928; judge accuses Loesch of "senile dementia," *Chicago Herald and Examiner*, July 22, 1928.

88. Bergreen, *Capone*, 294.
89. *Chicago Herald and Examiner*, September 8, 1928. Lombardo's murder, both *Chicago Tribune* and *Chicago Herald and Examiner*, September 8, 1928; *Chicago Daily News*, September 7, 1928; Pasley, *Al Capone*, 230; Lolordo's lying, *Chicago Herald and Examiner*, September 9, 1928.
90. Sanitary District goes broke and Timothy Crowe's testimony: *Chicago Herald and Examiner*, November 20 and December 28, 1928; January 23 and 24 and March 19, 1929.

6. 1929

91. Beer flats, *Chicago Herald and Examiner*, January 30, 1929.
92. Strawn's plan, *Chicago Tribune*, September 20, 1929; the city borrows $40 million, *Chicago Herald and Examiner*, April 4, 1929.
93. *Chicago Daily News*, July 14, 1930.

94. *Chicago Herald and Examiner*, February 15, 1929.

95. Violin case robbery, *Chicago Herald and Examiner*, March 7, 1929; viola cases, Yenne, *Tommy Gun*, 72–73.

96. Aiellos wanting Anselmi and Scalise killed, *Chicago Tribune*, May 18, 1929; the triple murders, *Chicago Tribune* and *Chicago Herald and Examiner*, both on May 9, 1929; Kobler, *Capone*, 245; Bergreen, *Capone*, 329–30; Schoenberg, *Mr. Capone*, 233–34.

97. Kolber, *Capone*, 246.

98. Ness, *Untouchables*, 7.

7. 1930–1933

99. Will Rogers's column, *American Heritage*, January 9, 1930.

100. *Chicago Herald and Examiner*, April 3 and July 11, 1931; and April 28, 1932

101. *Chicago Herald and Examiner*, February 8, 1931

102. Elizabeth Barnard's distress, thomasbarnard.com; Barnard's going to Randolph, *Chicago Herald and Examiner*, February 7, 1930; giving $75,000 to the IRS, Bergreen, *Capone*, 368; the Secret Six and the crime syndicate, *Chicago Herald and Examiner*, September 14, 1931.

103. *Chicago Herald and Examiner*, February 10, 1930.

104. *Chicago Tribune*, July 11, 1930.

105. *Chicago Herald and Examiner*, November 27, 1930.

106. *Chicago Herald and Examiner*, March 7, 1932.

107. Witness shootings, *Chicago Herald and Examiner*, January 19 and February 10, July 3, 11 and July 25, 1931; *Chicago Tribune*, June 9, 1931; *Chicago Herald and Examiner*, April 24 and 27, and October 12, 1931.

108. The "Jones 5 and 10" law explained, *Time*, March 25, 1929.

109. *Chicago Herald and Examiner*, June 20, 1932.

110. *Chicago Herald and Examiner*, November 2 and May 17, 1931.

111. Cohen and Taylor, *American Pharaoh*, 51.

112. Last sentence of Fitzgerald's essay "Echoes of the Jazz Age," in *Crack-Up*.

BIBLIOGRAPHY

Anonymous. *Ku Klux Klan Secrets Exposed*. Chicago: Esra Cook Publisher, 1922.

Barzini, Luigi. *The Italians*. New York: Bantam Books, 1965.

Bergreen, Laurence. *Capone: The Man and the Era*. New York: Simon & Schuster, 1995.

Bilek, Arthur J. *The First Vice Lord: Big Jim Colosimo and the Loose Ladies of the Levee*. Nashville, TN: Cumberland House, 2008.

Burkowski, Douglas. *Big Bill Thompson, Chicago and the Politics of Image*. Chicago: University of Chicago Press, 1998.

Burrough, Bryan. *Public Enemies: America's Greatest Crime Wave and the Birth of the FBI, 1933–1934*. London: Penguin Books, 2004.

Chalmers, David M. *Hooded Americanism: The First Century of the Ku Klux Klan, 1865–1965*. Garden City, NY: Doubleday & Co., 1965.

Cohen, Adam, and Elizabeth Taylor. *American Pharaoh: Mayor Richard J. Daley, His Battle for Chicago and the Nation*. New York: Little, Brown, 2000.

Cohn, Art. *The Joker Is Wild: The Story of Joe E. Lewis*. New York: Random House, 1955.

Eig, Jonathan. *Get Capone: The Secret Plot That Captured America's Most Wanted Gangster*. New York: Simon & Schuster, 2010.

Folsom, Robert G. *The Money Trail: How Elmer Irey and His T-Men Brought Doom to America's Criminal Elite*, Washington, D.C.: Potomac Books Inc., 2010.

Gillette, Paul J., and Eugene Tillinger. *Inside Ku Klux Klan*. New York: Pyramid Books, 1965.

Gottfried, Alex. *Boss Cermak of Chicago: A Study of Political Leadership*. Seattle: University of Washington Press, 1962.

Gradel, Thomas J., and Dick Simpson. *Corrupt Illinois, Patronage, Cronyism, and Criminality*. Springfield: University of Illinois Press, 2015.

Grossman, Mark. *Political Corruption in America: An Encyclopedia of Scandals, Power, and Greed*. Vol. 2. 2nd ed. Millerton, NY: Greyhouse Publishing, 2008.

Helmer, J. *Al Capone and His American Boys: Memoirs of a Mobster's Wife*. Indianapolis: Indiana University Press, 2011.

Irey, Elmer J., as told to William J. Slocum. *The Tax Dodgers*. New York: Greenburg, 1948.

Jackson, Kenneth. *The Ku Klux Klan in the City, 1915–1930*. New York: Oxford University Press, 1967.

Jobb, Dean. *Empire of Deception: The Incredible Story of a Master Swindler Who Seduced a City and Captivated the Nation*. Chapel Hill, NC: Algonquin Books, 2015.

Keefe, Rose. *Guns and Roses: The Untold Story of Dean O'Brien, Chicago's Big Shot Before Al Capone*. Nashville, TN: Cumberland House, 2003.

———. *The Man Who Got Away: The Bugs Moran Story*. Nashville, TN: Cumberland House, 2005.

Kobler, John. *Capone: The Life and World of Al Capone*. New York: Fawcet Crest, 1972.

Lesey, Michael. *Murder City*. New York: W.W. Norton & Company, 2007.

Lindburg, Richard C. *To Serve and Collect: Chicago Politics and Police Corruption from the Lager Beer Riot to the Summerdale Scandal*. New York: Praeger Publishers, 1991.

Lombardo, Robert M. *The Black Hand: Terror by Letter in Chicago*. Chicago: University of Illinois Press, 2010.

Lyle, John H. *The Dry and Lawless Years*. New York: Dell Publishing, 1961.

Masters, Edgar Lee. *The Tale of Chicago*. New York: G.P. Putnam's Sons, 1930.

McPhaul, Jack. *Johnny Torrio: First of the Gang Lords*. New Rochelle, NY: Arlington House, 1971.

Nelli, Humphrey S. *Italians in Chicago, 1880–1930: A Study in Ethnic Mobility*. New York: Oxford University Press, 1979.

Ness, Eliot, with Oscar Fraley. *The Untouchables*. New York: Popular Library, 1960.

Pasley, Fred. *Al Capone: The Biography of a Self-Made Man*. New York: Ives Washburn, 1930.

Peck, Garrett. *Prohibition in Washington, D.C.: How Dry They Weren't*. Charleston, SC: The History Press, 2011.

Peterson, Virgil W. *Barbarians in Our Midst: A History of Chicago Crime and Politics*. Boston: Little, Brown & Company, 1952.

Philpott, Thomas Lee. *The Slum and the Ghetto: Neighborhood Deterioration and Middle-Class Reform, 1880–1930*. New York: Oxford University Press, 1978.

Piertrusza, David. *Judge and Jury: The Life and Times of Judge Kenesaw Mountain Landis*. South Bend, IN: Diamond Communications, 1998.

Rice, Arnold. *The Ku Klux Klan in American Politics*. Washington, D.C.: Public Affairs Press, 1962.

Riddings, John. *Len Small: Governors and Gangsters*. Herscher, IL: Side Show Books, 2009.

Schmelter, Richard J. *Chicago Assassin: The Life and Legend of "Machine Gun" Jack McGurn and Chicago's Beer Wars of the Roaring Twenties*. Nashville, TN: Cumberland House, 2007.

Schmidt, John R. *The Mayor Who Cleaned Up Chicago: A Political Biography of William E. Dever*. DeKalb, IL: Northern Illinois University Press, 1983.

Schoenberg, Robert J. *Mr. Capone*. London: Robson Books, 1995.

Stuart, William H. *The Twenty Incredible Years*. New York: M.A. Donohue & Co., 1935.

Touhy, Roger, with Ray Brennan. *The Stolen Years*. Cleveland, OH: Pennington Press, 1959.

Tuohy, John W. *When Capone's Mob Murdered Roger Touhy: The Strange Case of Touhy, Jake the Barber, and the Kidnapping That Never Happened*. Fort Lee, NJ: Barricade Books, 2001.

Wade, Wyn Craig. *The Fiery Cross: The Ku Klux Klan in America*. New York: Simon and Schuster, 1987.

Wendt, Lloyd, and Herman Kagan. *Big Bill of Chicago*. New York: Bobbs-Merrill Co., 1953.

Wigmore, J.H., ed. *Illinois Crime Survey*. Chicago: Illinois Association of Criminal Justice, 1929.

Yenne, Bill. *Tommy Gun: How General Thompson's Submachine Gun Wrote History*. New York: Thomas Dunne Books, St. Martin's Press, 2009.

PERIODICALS, ESSAYS, REPORTS, ETC.

Bennett, James O'Donnell. "Chicago Gangland: The True Story of Its Murders, Its Vices, and Its Reprisals." *Chicago Tribune*, February 24 and March 3, 1929.

Doherty, James. "I Remember" series. *Chicago Tribune*. February 4, 11, 18, and 25; March 4, 18, 25; April 1, 7, 15; and May 6, 1951.

Fitzgerald, F. Scott. *The Crack-Up*. New York: James Laughlin, 1945.

"Gangland Style Murders 1919–1983," a list entered as Exhibit 1 in Chicago Crime Commission testimony before the U.S. Sub-Committee on Organized Crime, March 4, 1983.

Johnson, Alva. *New Yorker*. August 25, 1928.

Lombardo, R.M. "The Black Mafia: African American Organized Crime in Chicago, 1890–1960." *Crime, Law & Social Change*, no. 38, 2002.

Petranik, Stephen. "Al Capone's 1928 Gangster Car." *American History*, February 2012.

"Politics; Go to Hell." *Time*, April 9, 1928.

Puttkamer, E.W. "Recent Developments in the Chicago Police Department." *Chicago Crime Commission*, Spring 1935.

Schwarb, Richard D. "The Civil Aspects of Net Worth Method." *William & Mary Review* 3 (October 1961).

Vanderbilt, Cornelius, Jr. "How Capone Would Run This Country." *Liberty* magazine, October 1931.

ABOUT THE AUTHOR

Wayne Klatt is a retired Chicago journalist who writes about crime and local history.